LOVE DOGS of SEDONA

by Alisann Smookler, Artist

Sedona, AZ is a magical and magnificently beautiful village. To experience the Red Rocks is to take a moment to breathe in the sweet air that brings one to calm in a very transformative way.

As an artist I love painting and drawing dogs. I have taken my passion for art and dogs and combined them into a coloring book for adults that I hope you will enjoy.

The unique energy of Sedona will lift your spirits and provides ever-lasting memories. Dogs have the same effect. And coloring can provide a calming form of meditation that will calm any stress. The dogs in this book are as unique as the beauty of Sedona.

It was through my own healing from brain cancer that I discovered the healing modality of coloring.

All Dogs have a Story and I tell it in Color!©

Hugs -

Alisann and Abee (Dog in Residence)

Studio—Sedona, AZ

Love Dogs of Sedona

This book features single-sided coloring pages. There are doodles within the hand-drawn dogs that represent meditation symbols and icons. They represent such emotions and modalities as the Lotus flower, Beads, Buddha, Strength, Loyalty, Empowerment, Joy, Surrender and Believing. Along with the portrait of the dog, they contain quotes about our love for dogs.

I hope you enjoy coloring this book as much as I loved drawing each furry face. I invite you to get your coloring tools and enjoy a coloring

meditative experience.

In this grouping of dogs I have included Hamsas and coloring pages that reflect the symbols of Sedona.

Namaste'

Many of the dogs have a heart drawn in them as I do in all my dog books.

Artist—Alisann Smookler

All Rights Reserved©2017

www.artbyalisann.com

ARTIST NOTE

When we color there are no rules. Color inside the lines or outside the lines. Add any element you may want in your coloring or don't.

It is yours to color and becomes your art.

Have fun and let everything go when coloring.

Enjoy the experience!

If you use any WET medium (gels, watercolor pens, markers) when coloring these pages, be sure to place a *Bleed Sheet* behind your coloring page so the WET medium does not bleed through and damage your next coloring page.

When using a DRY medium (pencils) a bleed sheet is not necessary.

All the images in this book are the sole property of Art by Alisann.

All Rights Reserved©2017

They may not be duplicated in any form without the express written permission of the Artist—Alisann Smookler Art by Alisann

Dogs are our link to paradise. They don't know evil or jealousy or discontent. To sit with a dog on a hillside on a glorious afternoon is to be back in Eden, where doing nothing was not boring—it was peace.

—Milan Kundera

This book is dedicated to Abee

Our amazing Catahoula who gives us so much Joy!

When I am in my Studio, she is next to me as I create.

She is my Muse

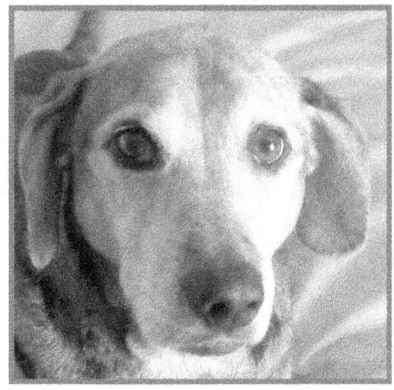

Dog Breeds in book

Shih-Tzu

Chihuahua

Pitbull

Pug

King Charles Cavalier

Peruvian Inca Orchid

Chinese Crested Dog

Xoloitzcuintli Mexican Hairless

Long-haired Dachshund

Border Collie

Australian Cattle Dog

Skye Terrier

Dixie Dingo

Rescue Mix—Mutt

Catahoula Leopard Hound

Bedlington Terrier

Lund Hound

Chow Chow

Basset Hound

Beagle

English Bulldog

Phu Quoc Ridgeback

Boerboel

Greyhound

Doberman Pinscher

Cane Corso

Bull Mastiff

Thai Ridgeback

Neapolitan Mastiff

Catalburun

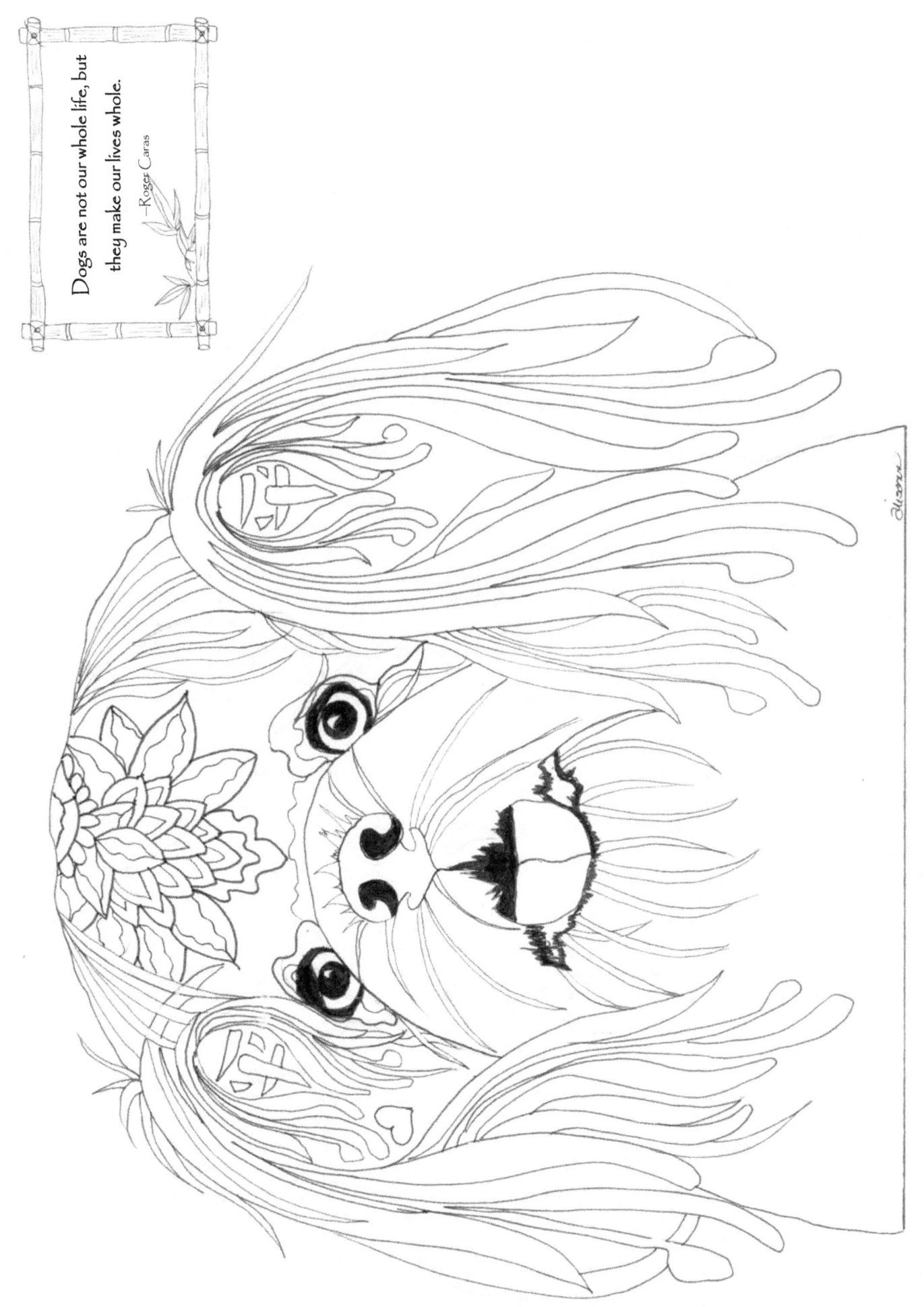

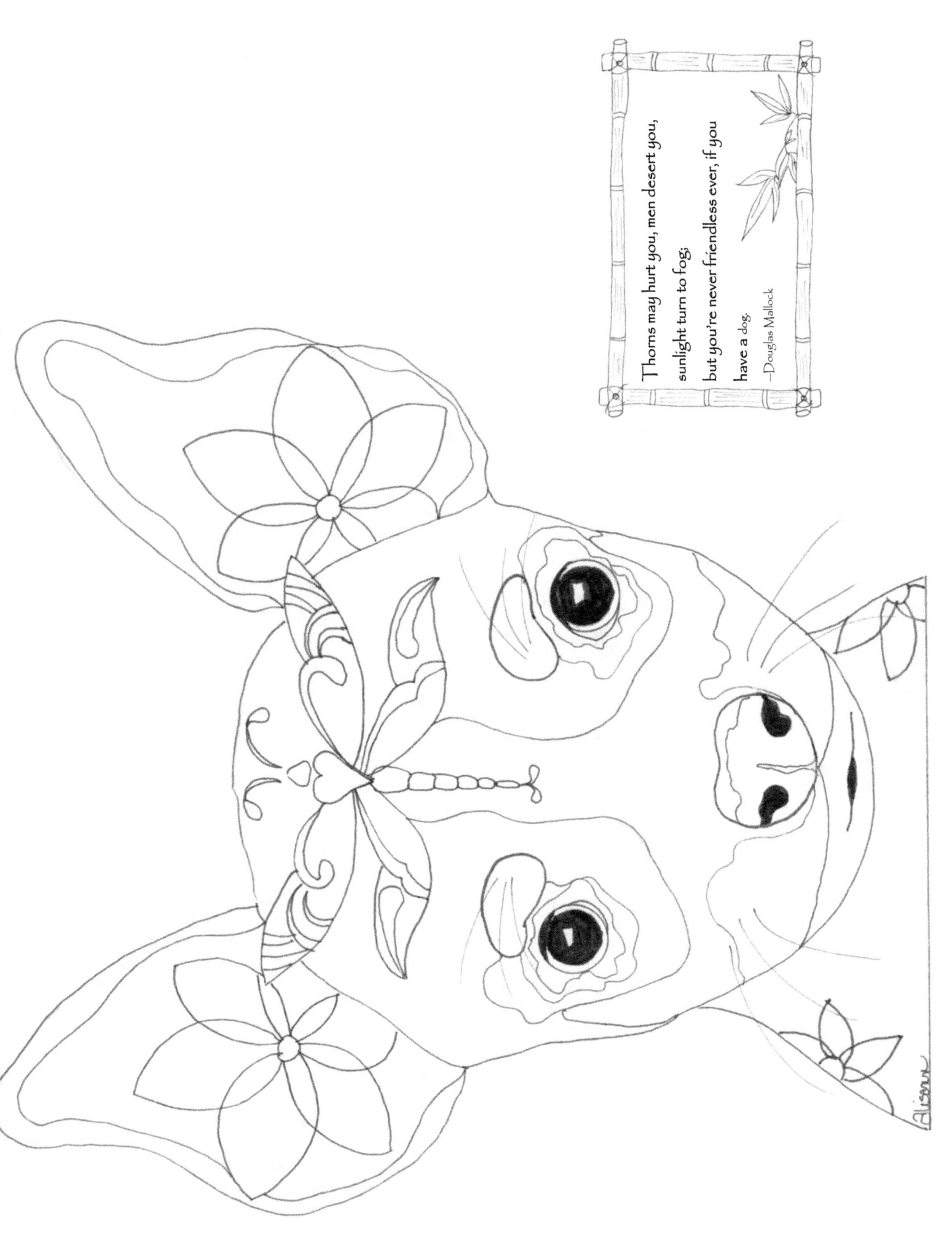

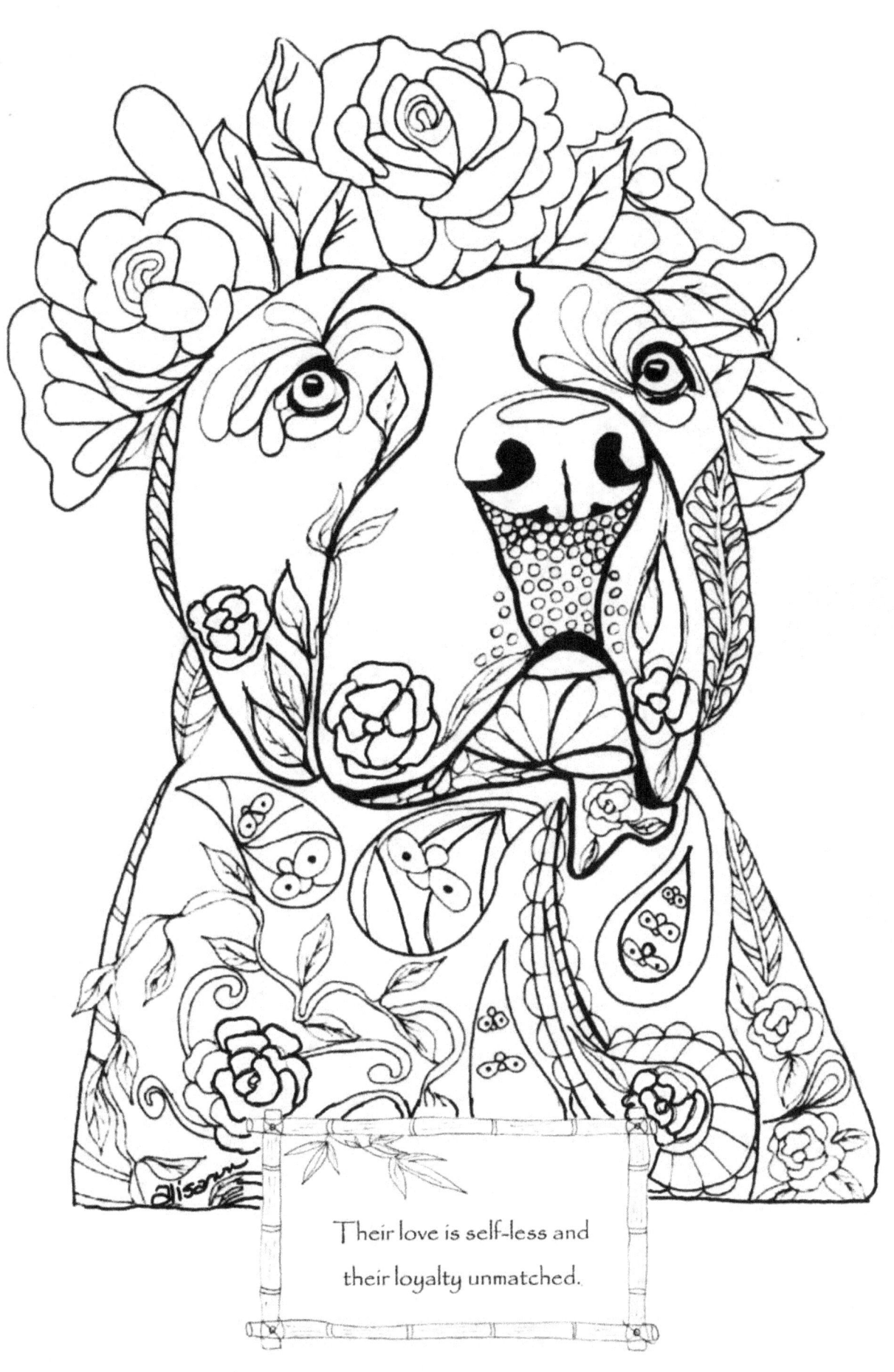

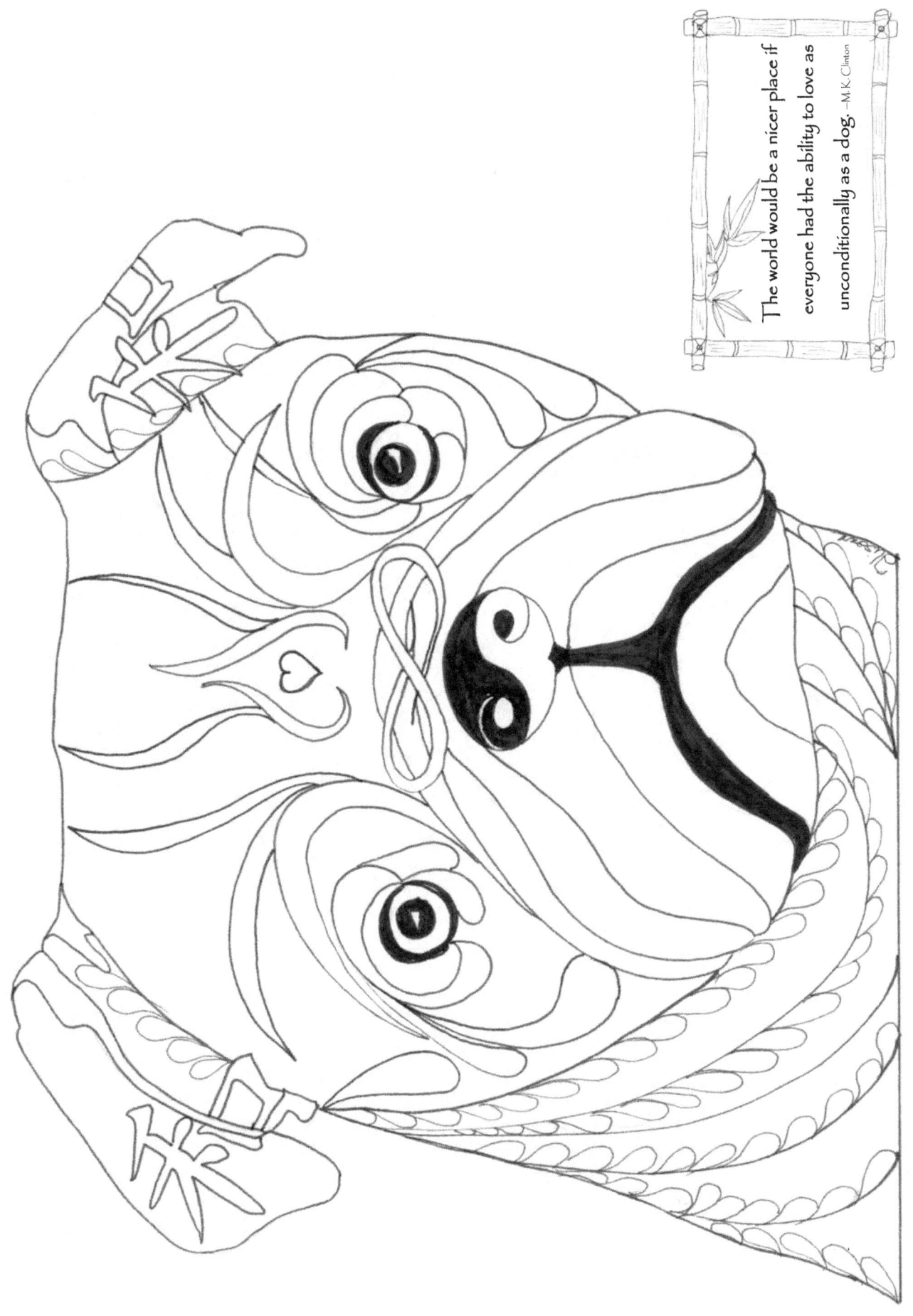

The world would be a nicer place if everyone had the ability to love as unconditionally as a dog. —M.K. Clinton

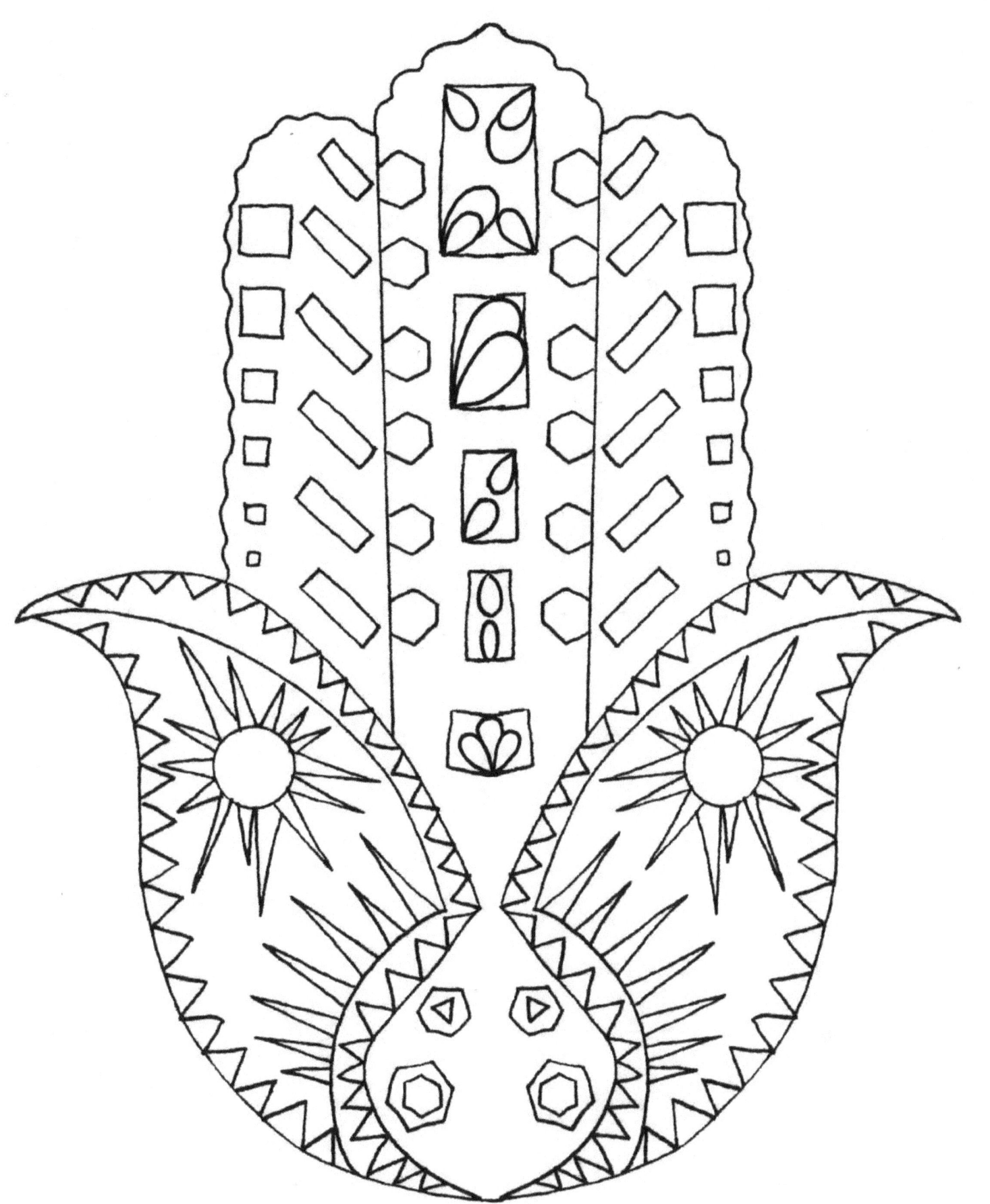

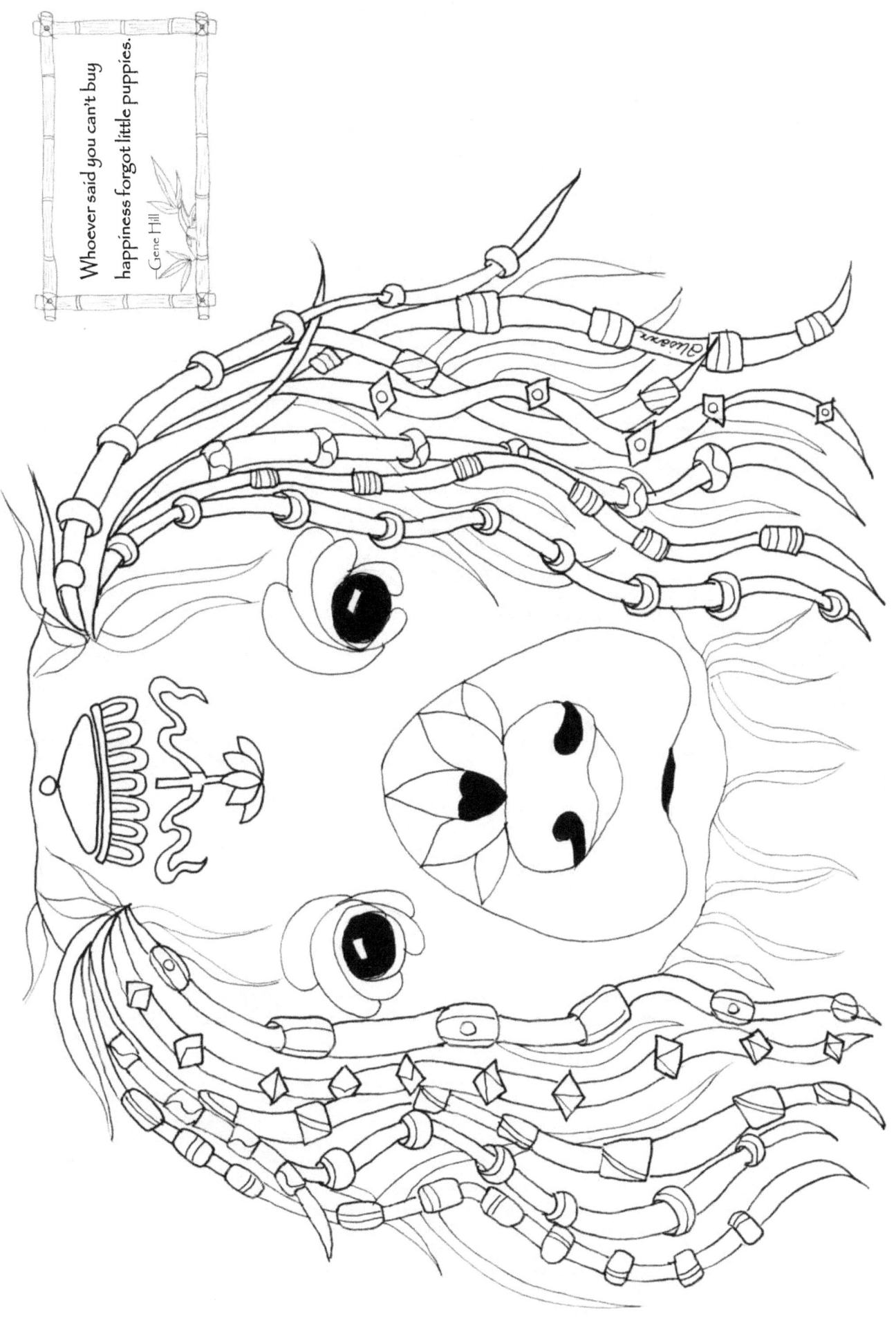

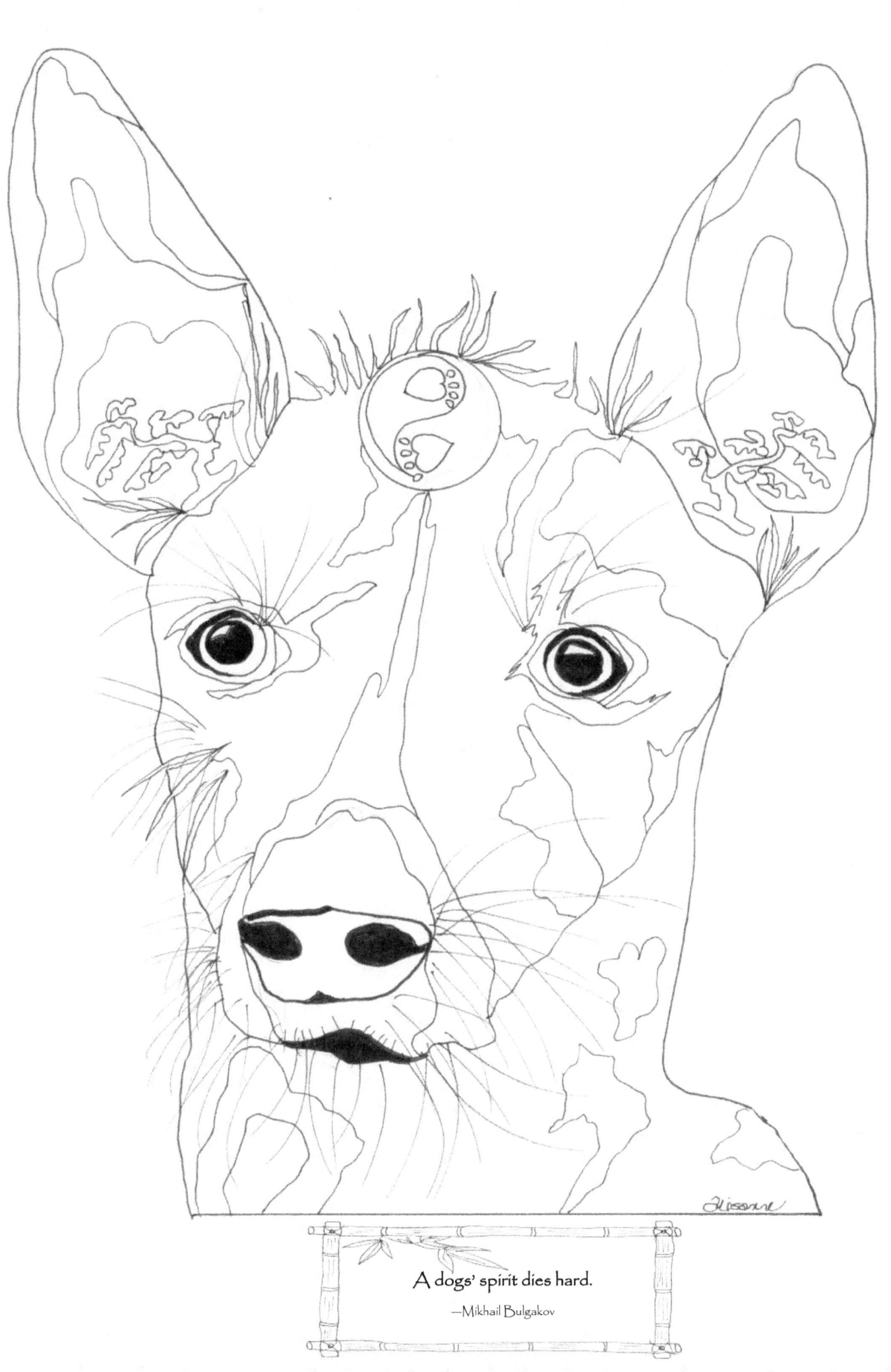

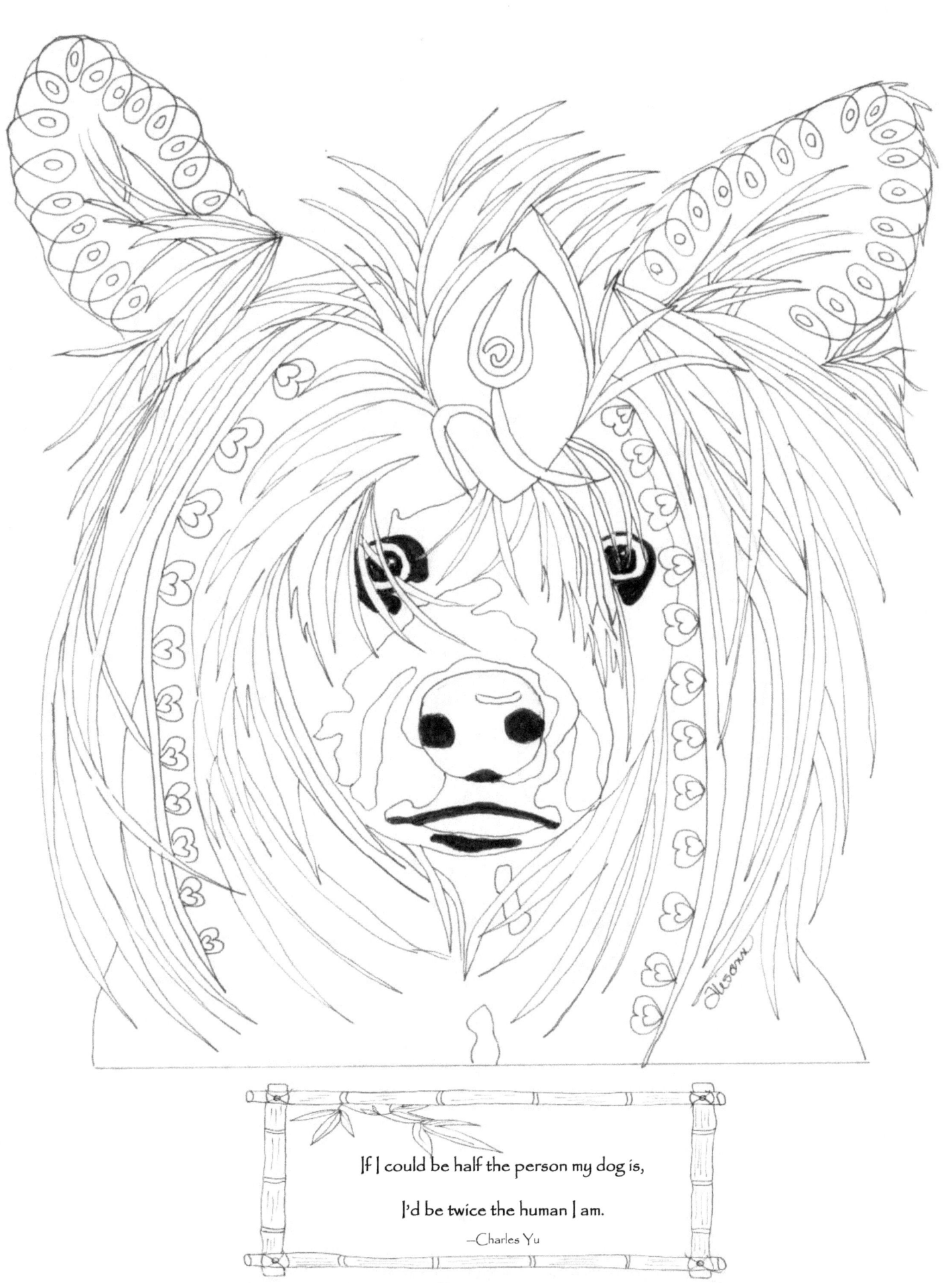

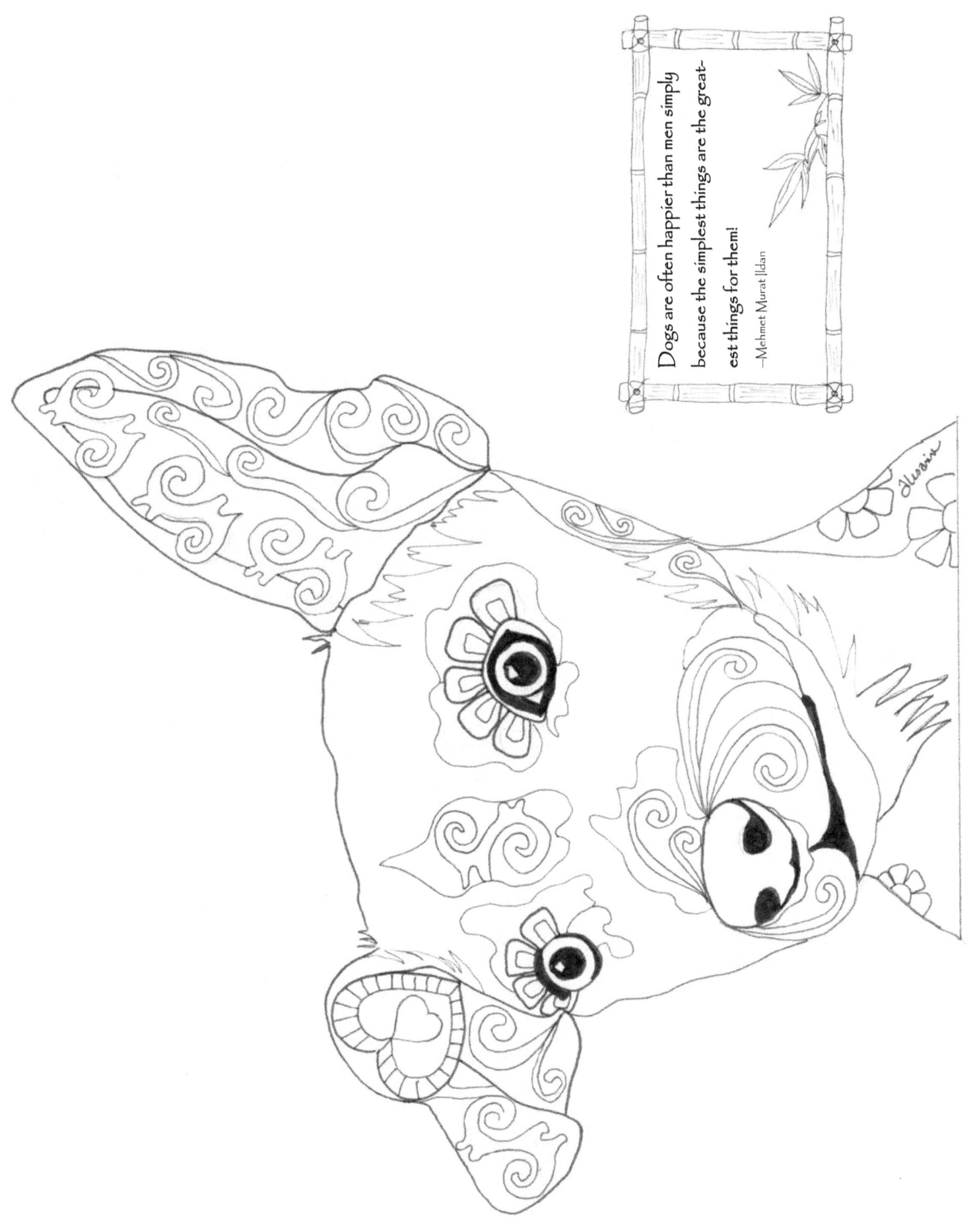

I'm not alone, said the boy. I've got a puppy.
—Jane Thayer

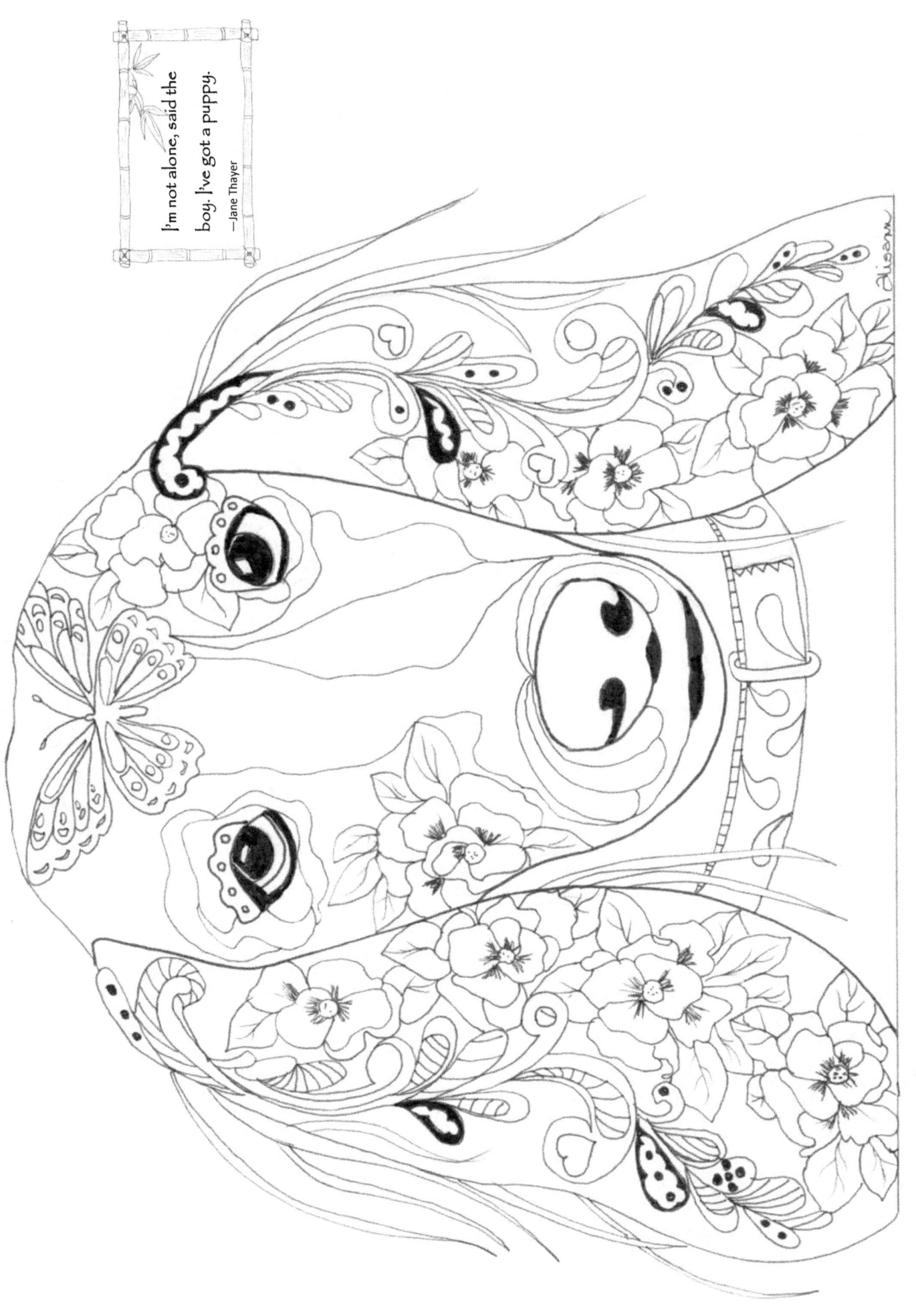

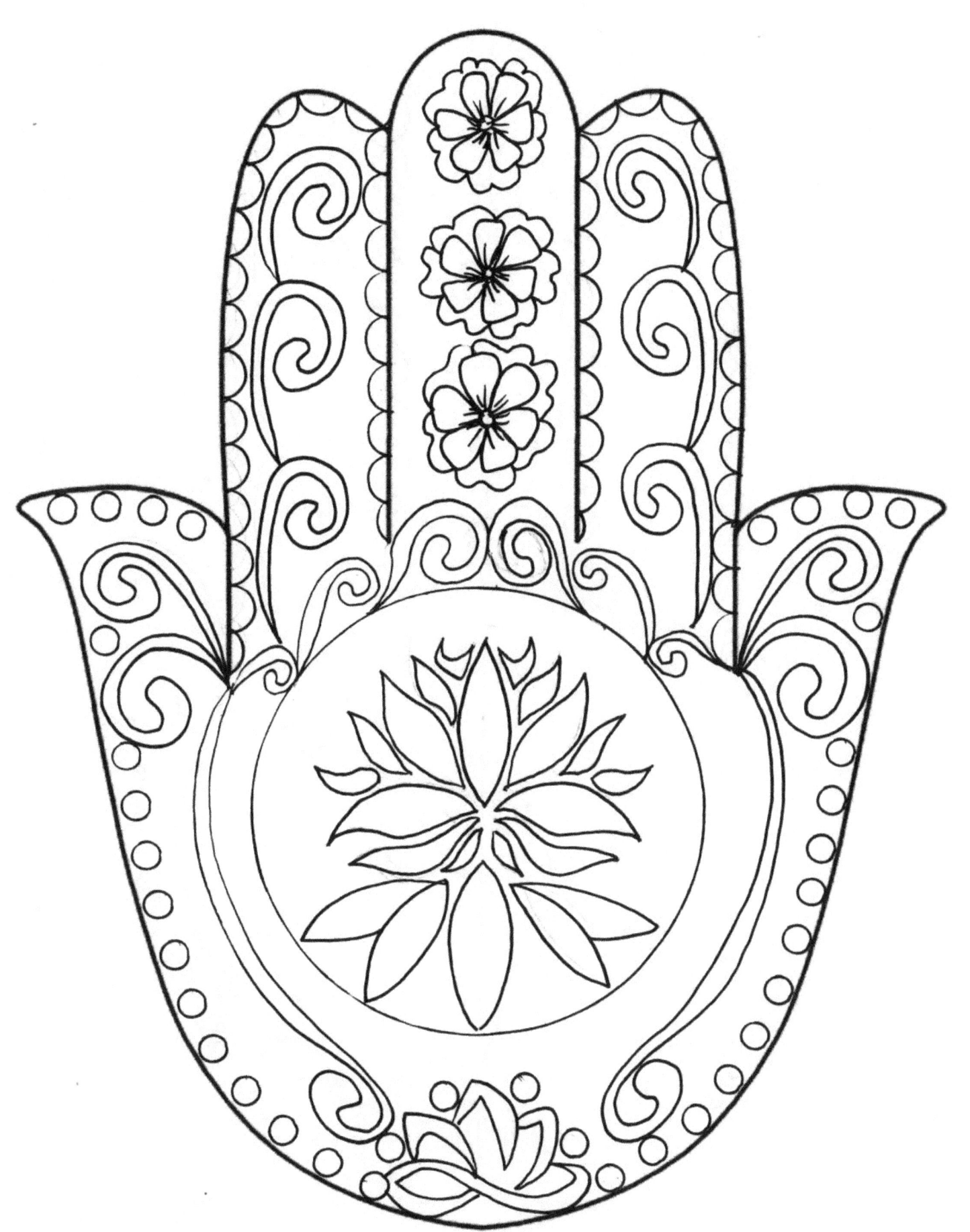

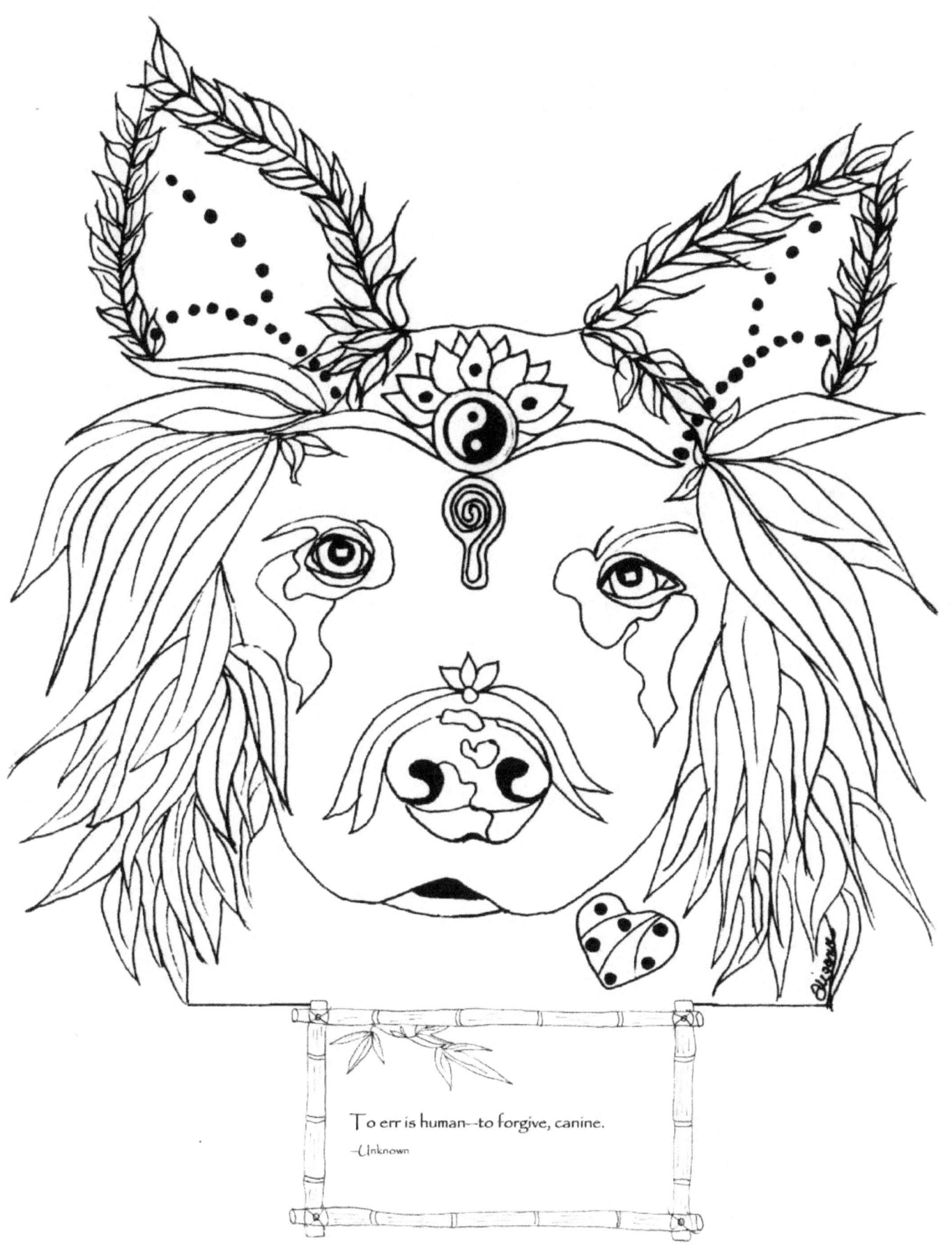

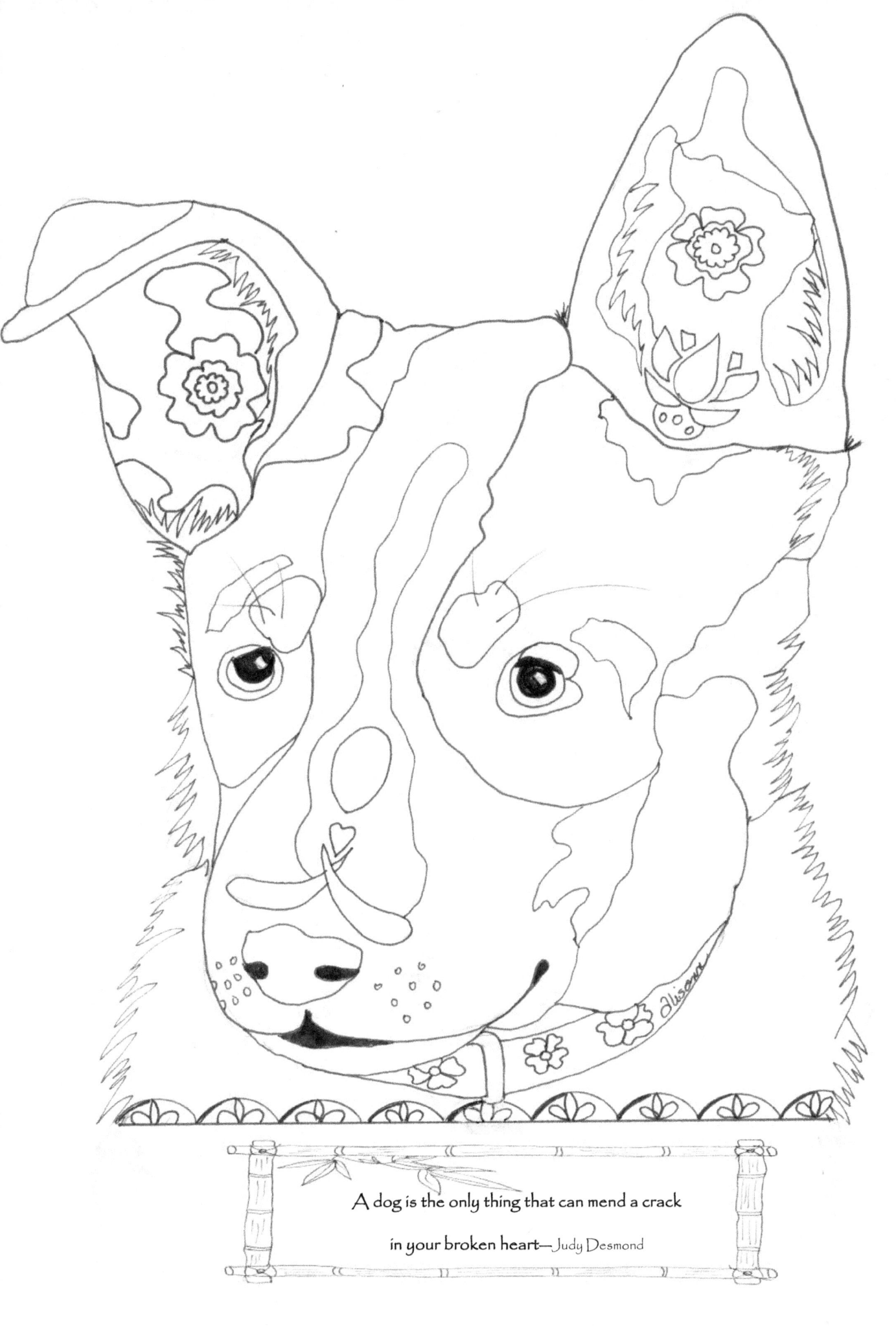

A dog is the only thing that can mend a crack in your broken heart—Judy Desmond

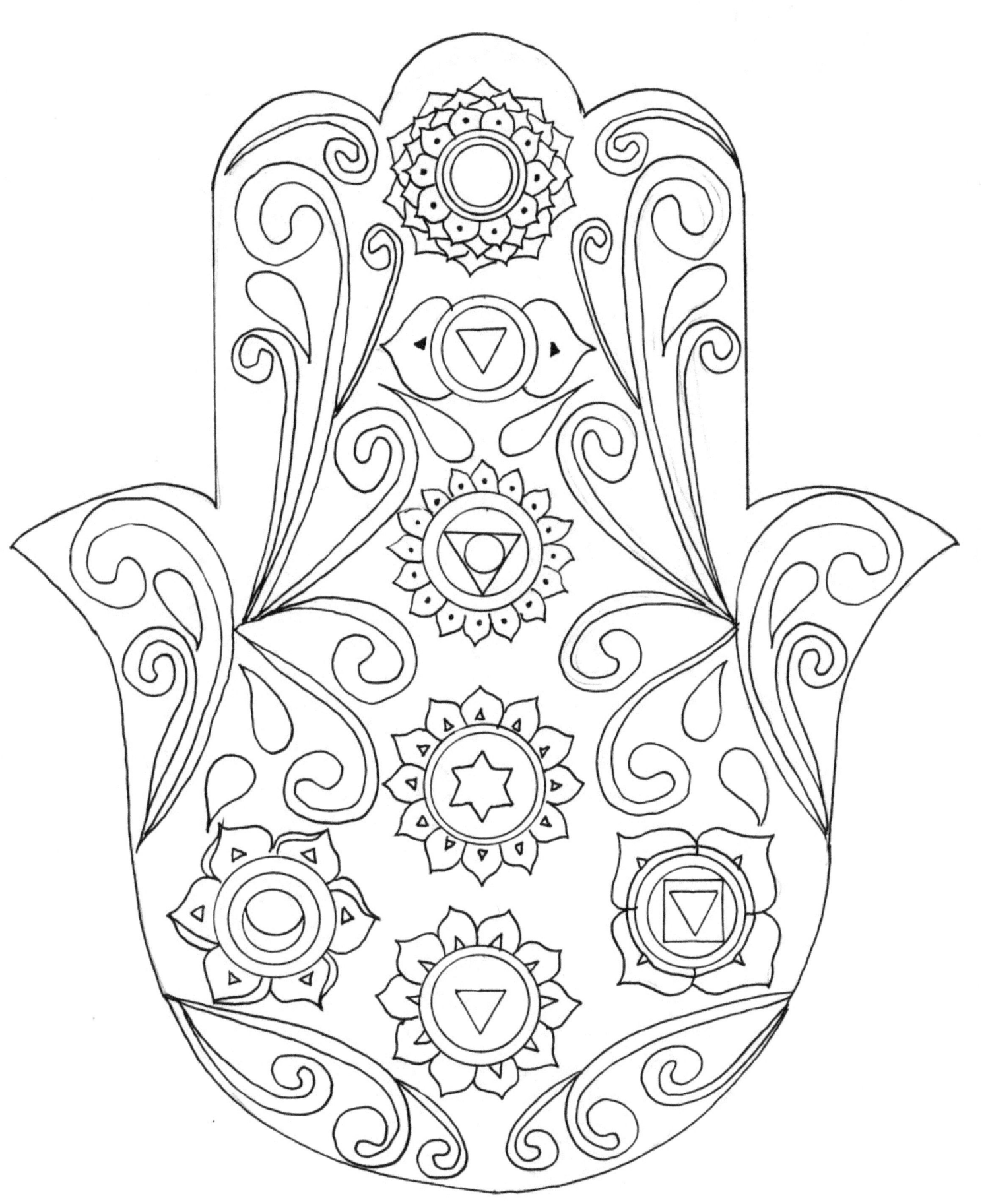

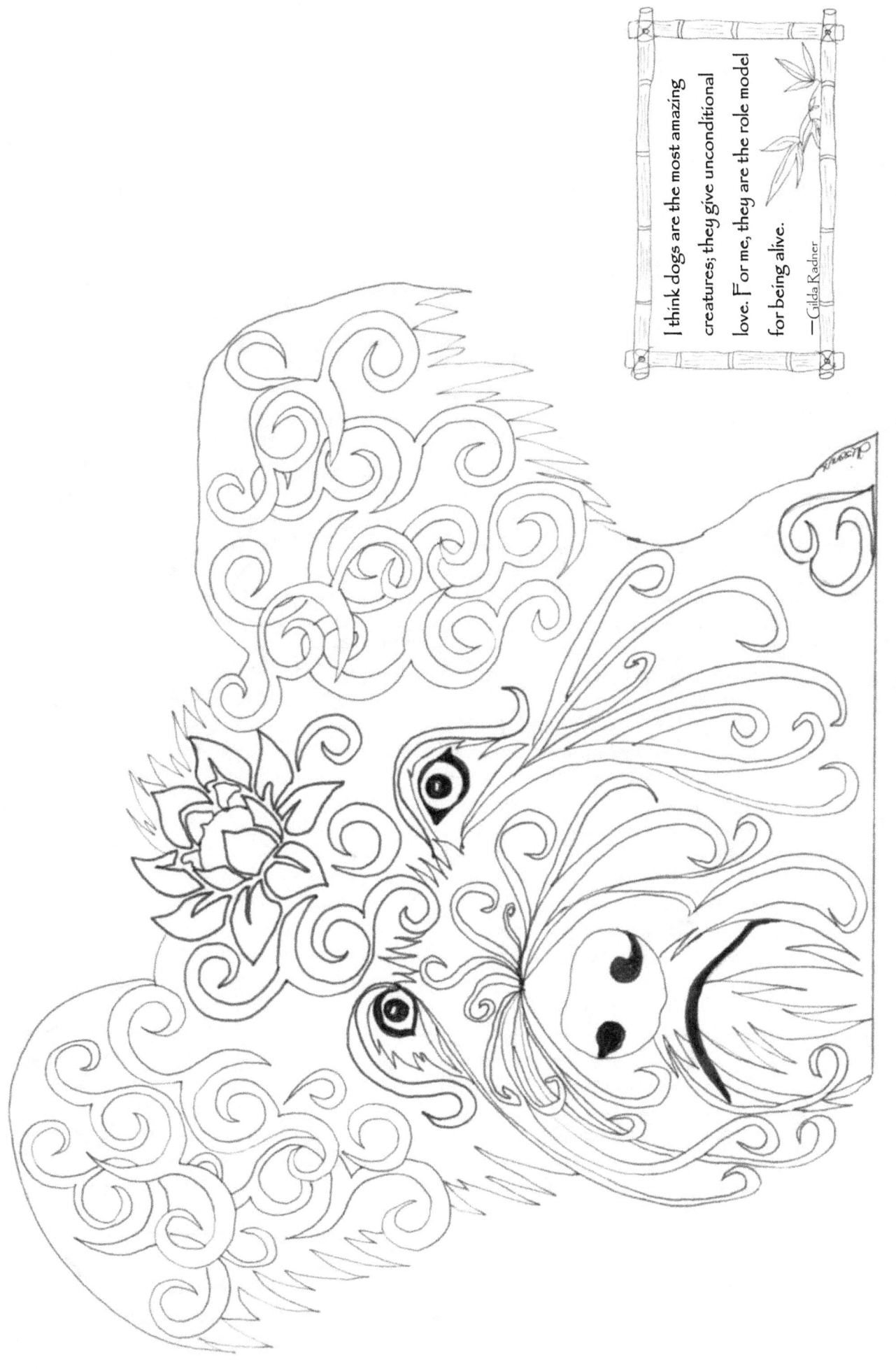

I think dogs are the most amazing creatures; they give unconditional love. For me, they are the role model for being alive.
—Gilda Radner

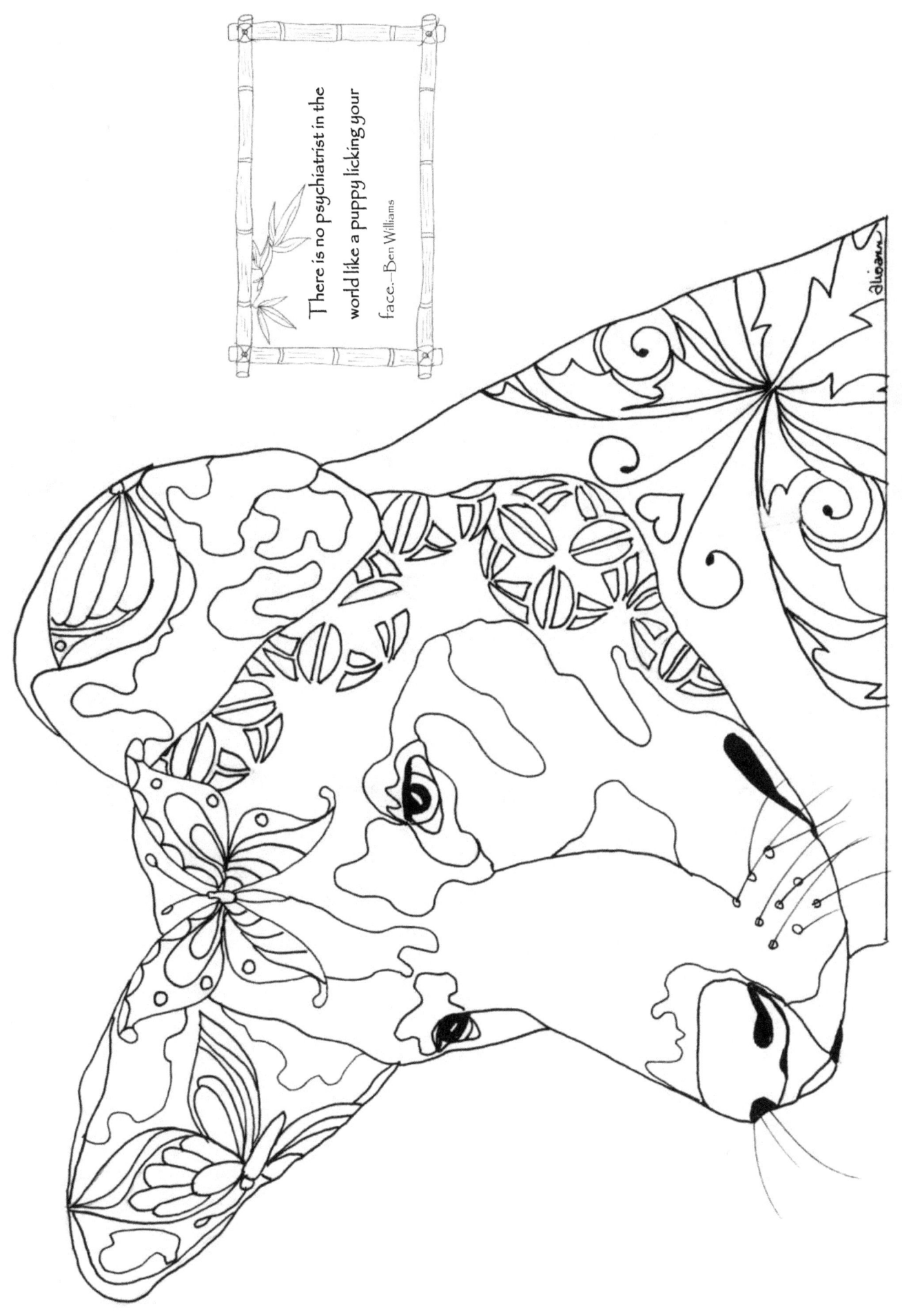

There is no psychiatrist in the world like a puppy licking your face. —Ben Williams

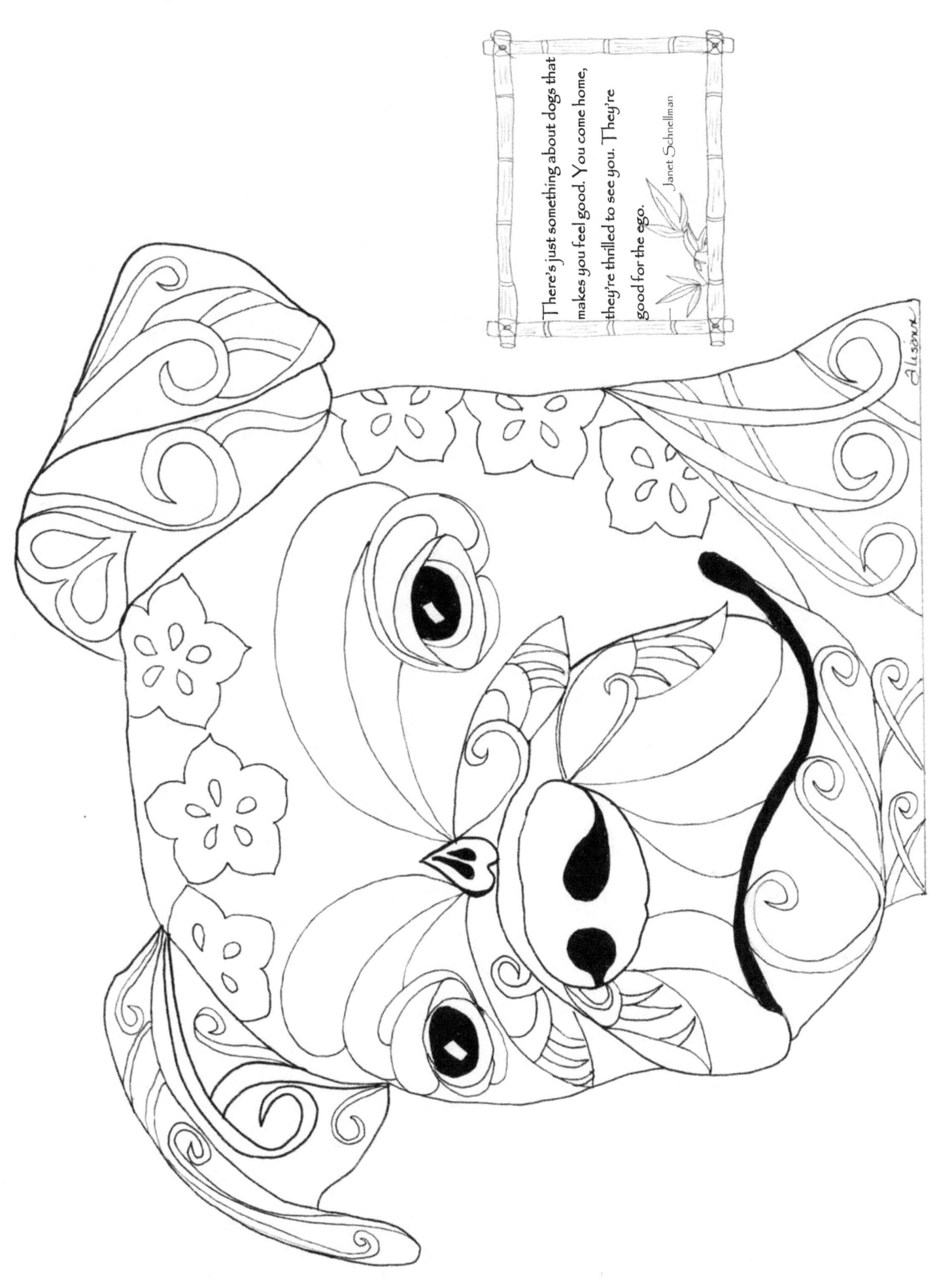

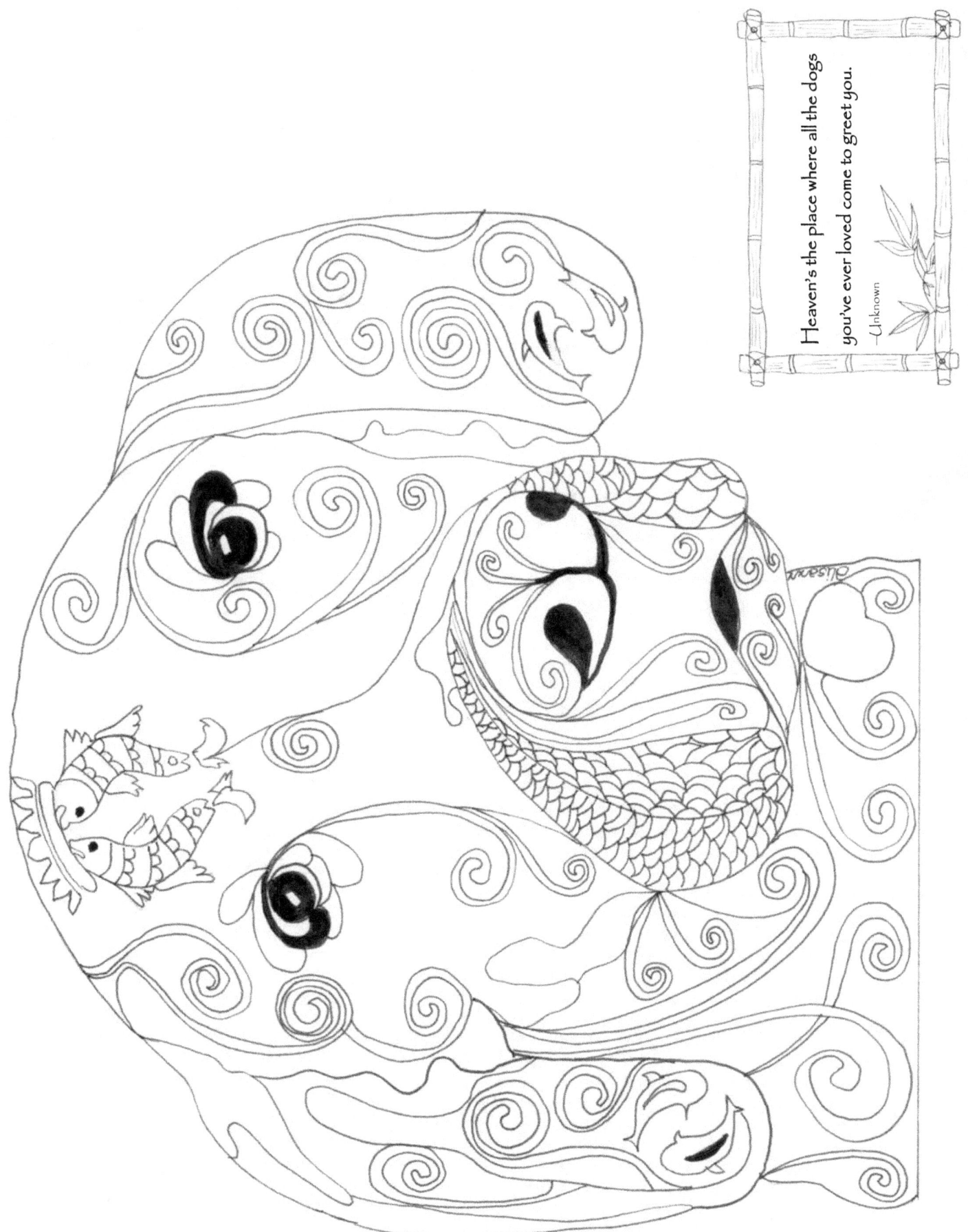

Heaven's the place where all the dogs you've ever loved come to greet you.
—Unknown

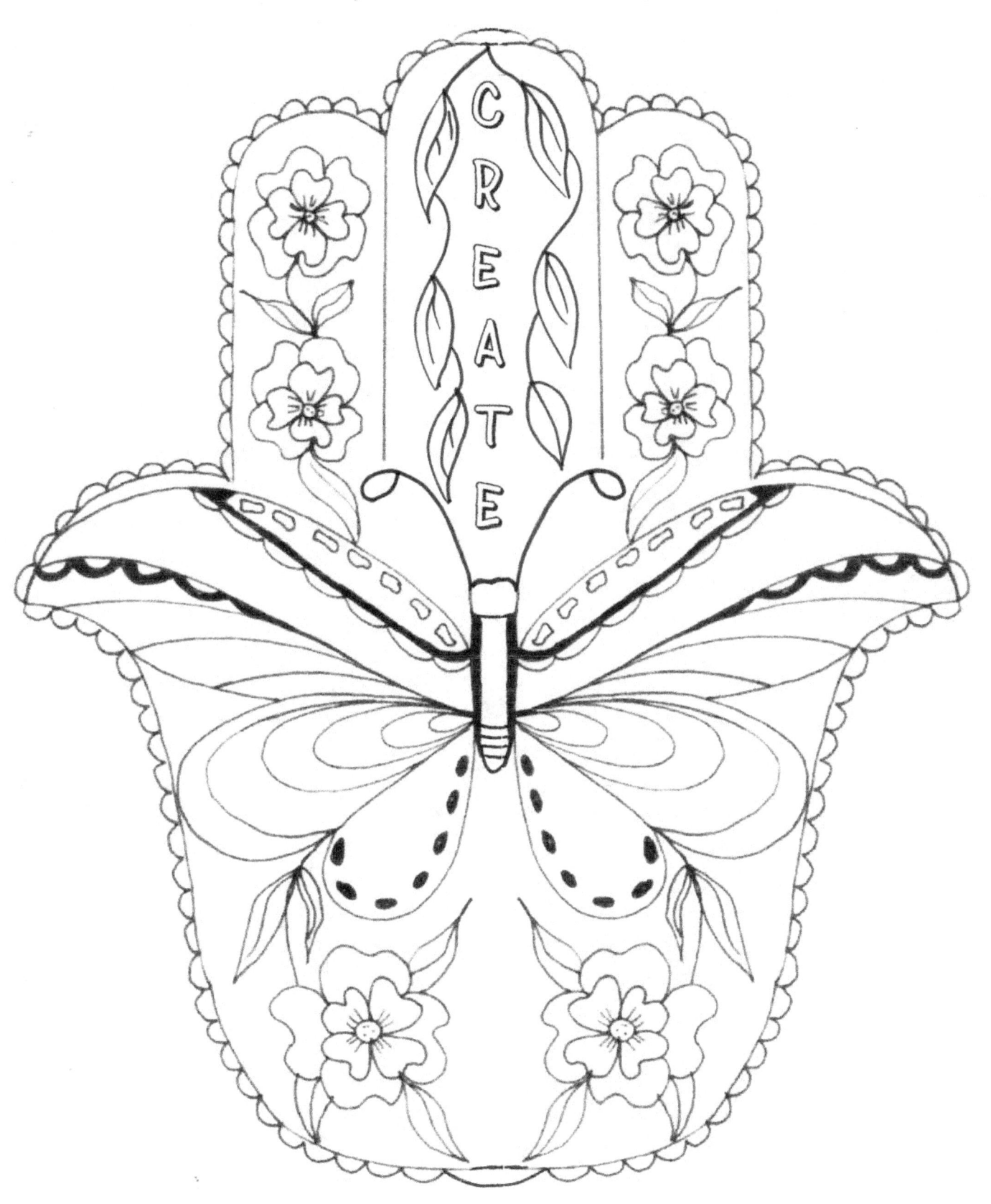

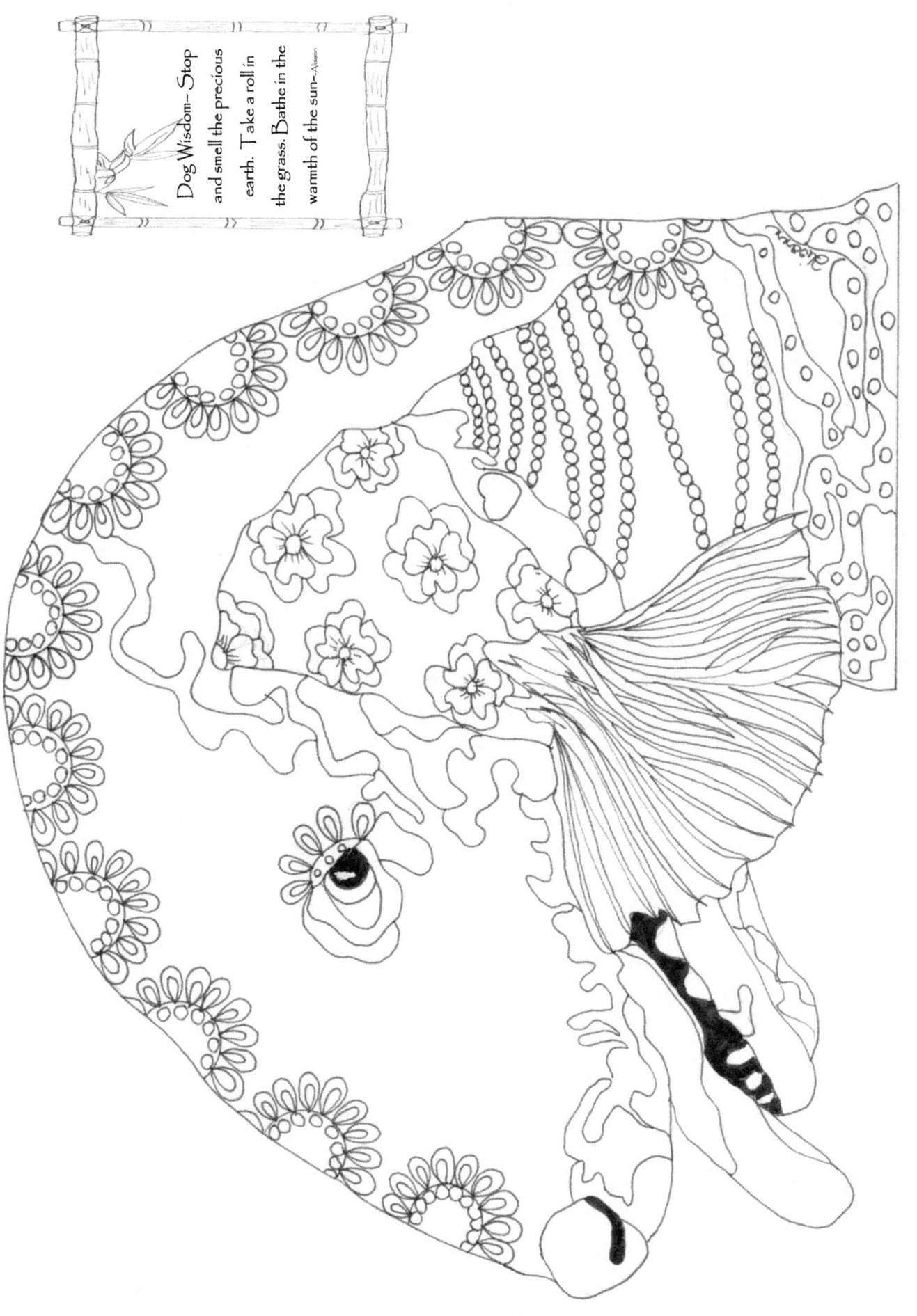

Dog Wisdom— Stop and smell the precious earth. Take a roll in the grass. Bathe in the warmth of the sun.—Alearn

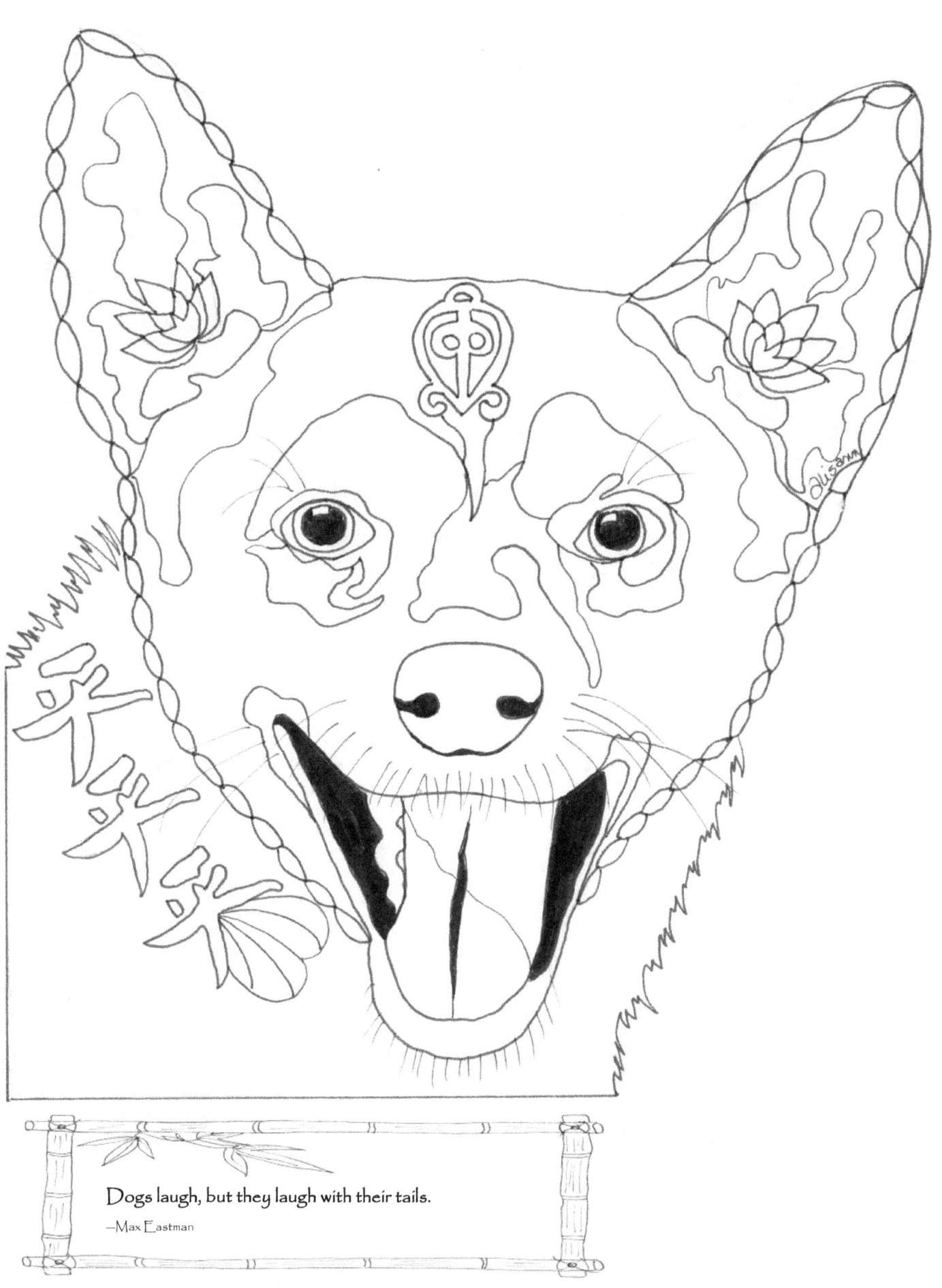

Dogs laugh, but they laugh with their tails.
—Max Eastman

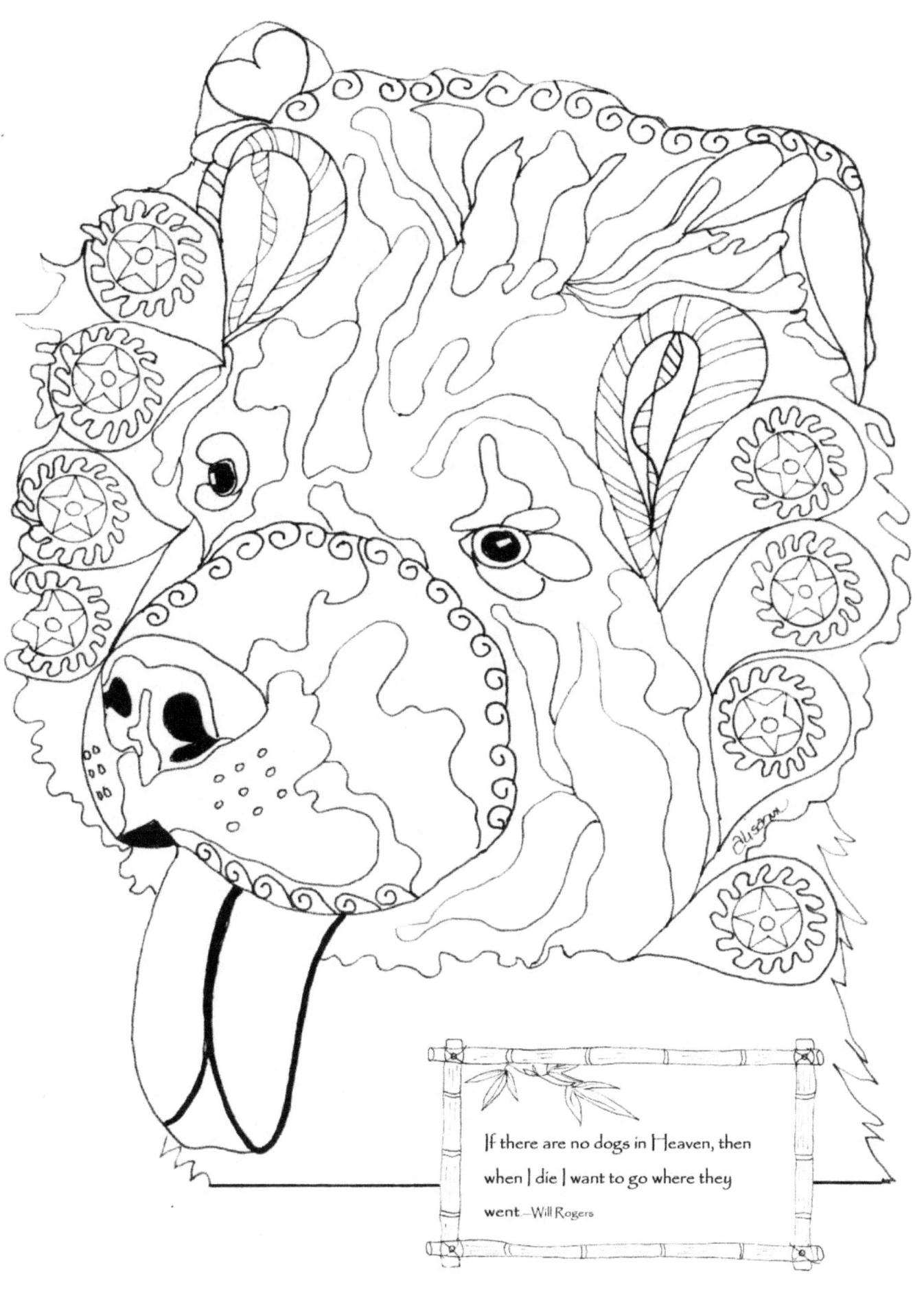

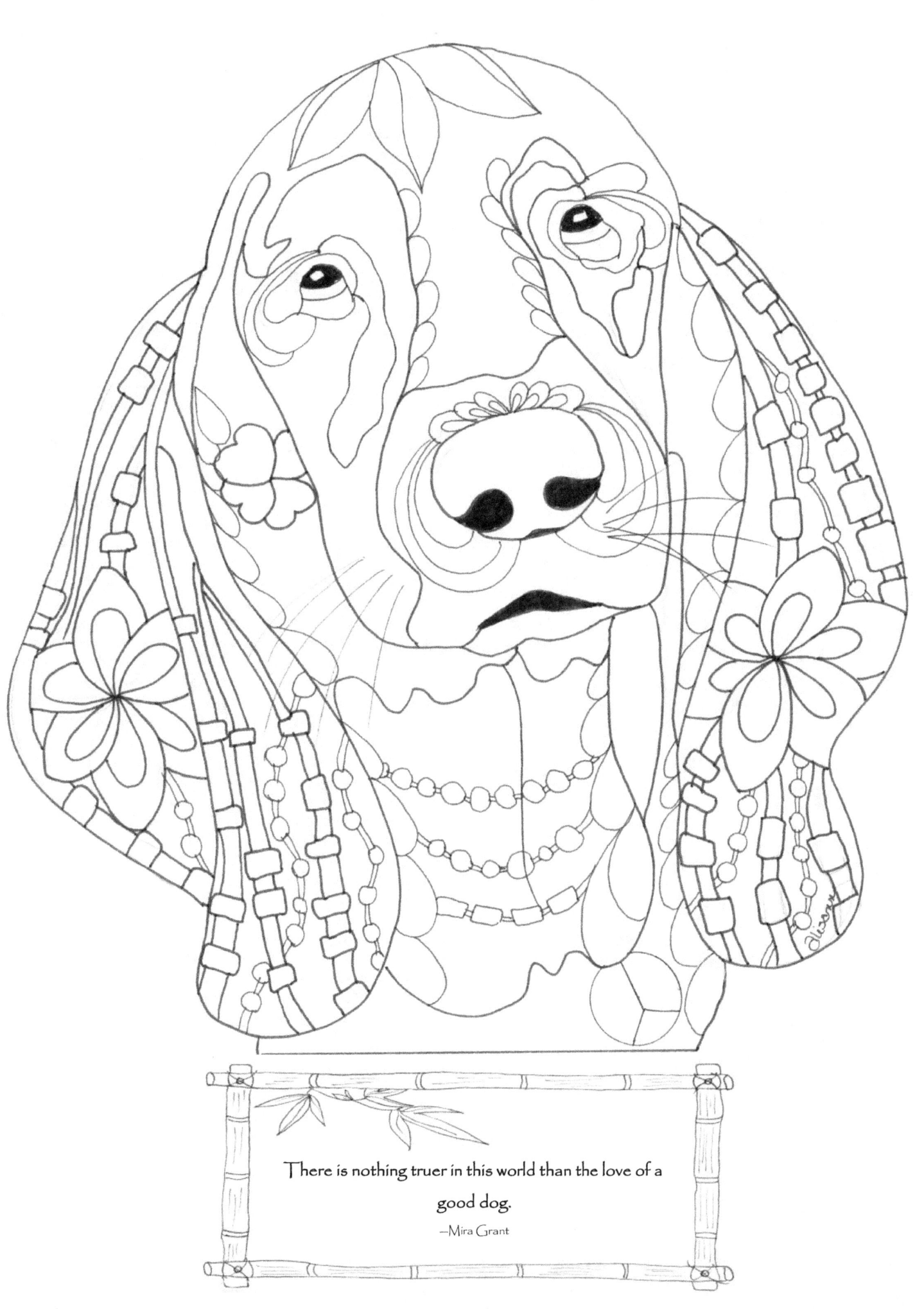

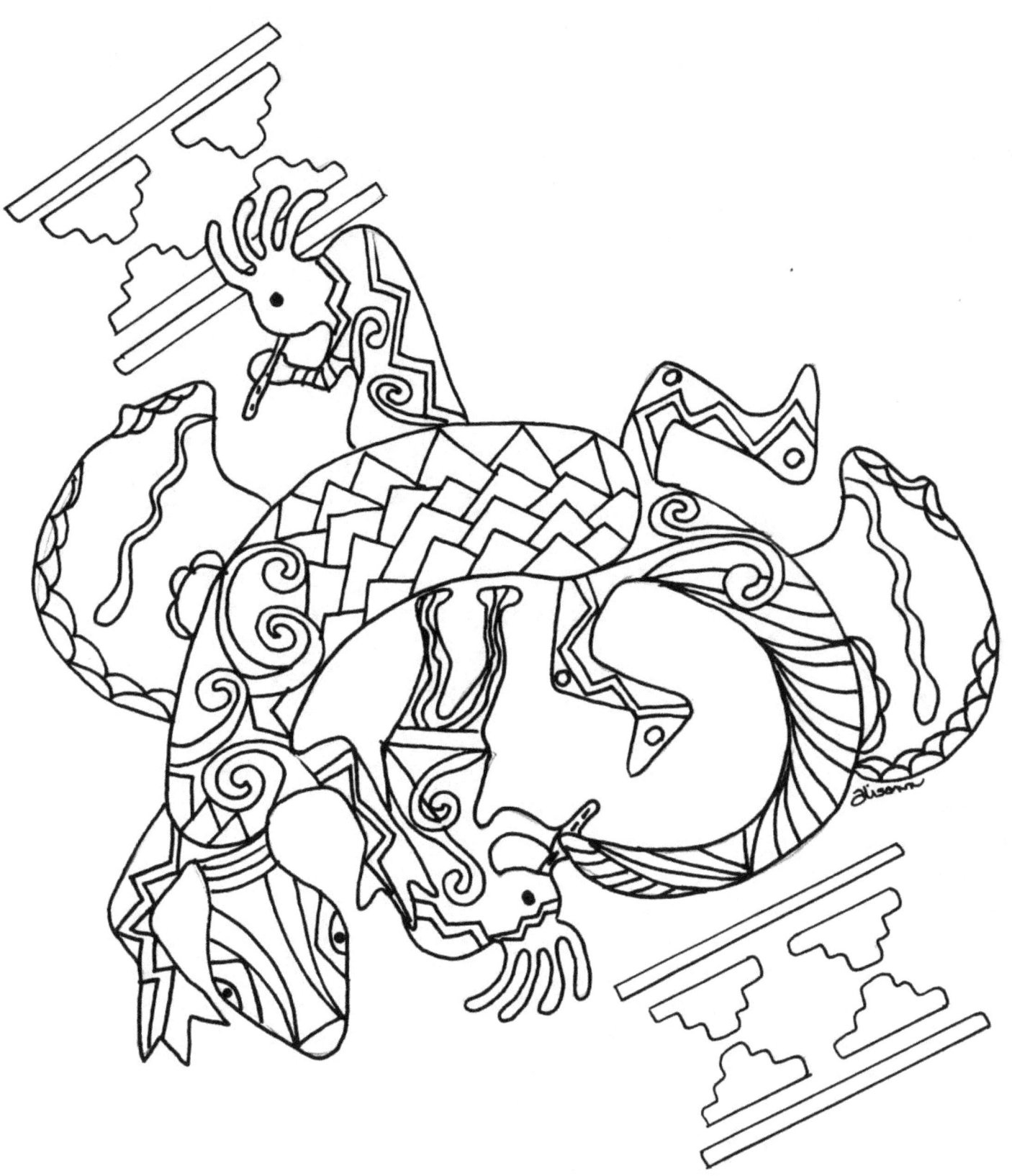

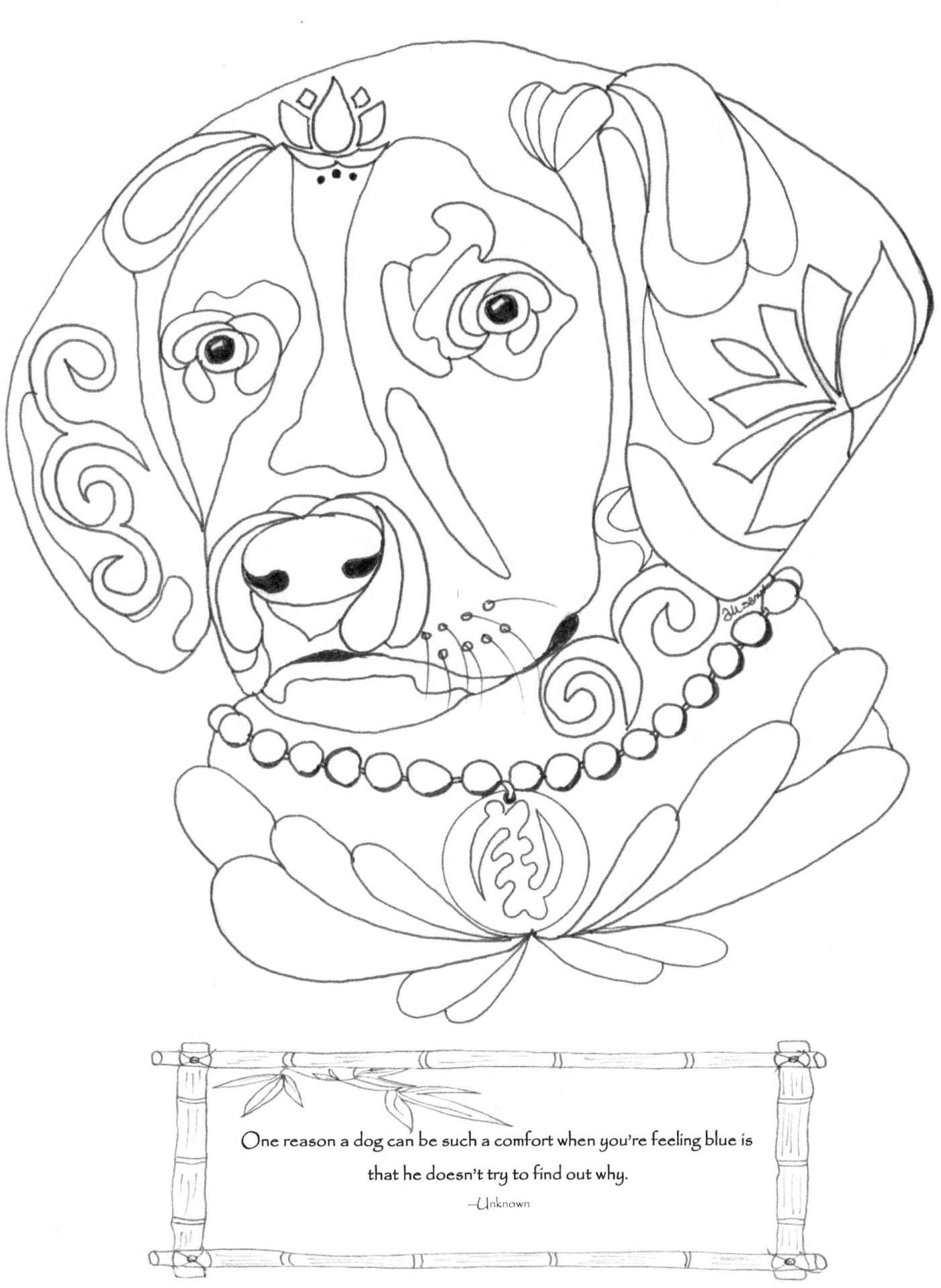

One reason a dog can be such a comfort when you're feeling blue is that he doesn't try to find out why.

—Unknown

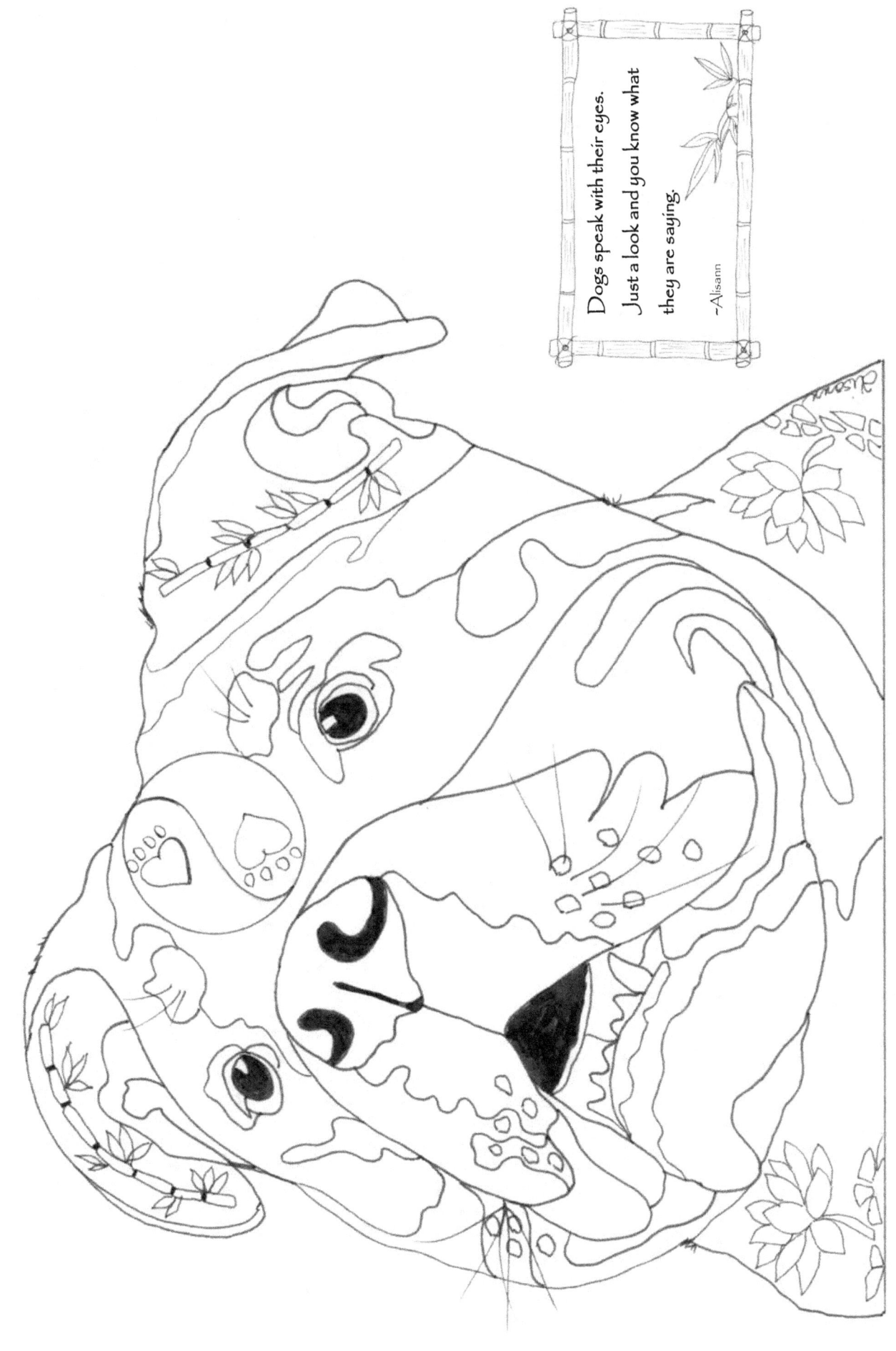

Dogs speak with their eyes. Just a look and you know what they are saying.
~Alisann

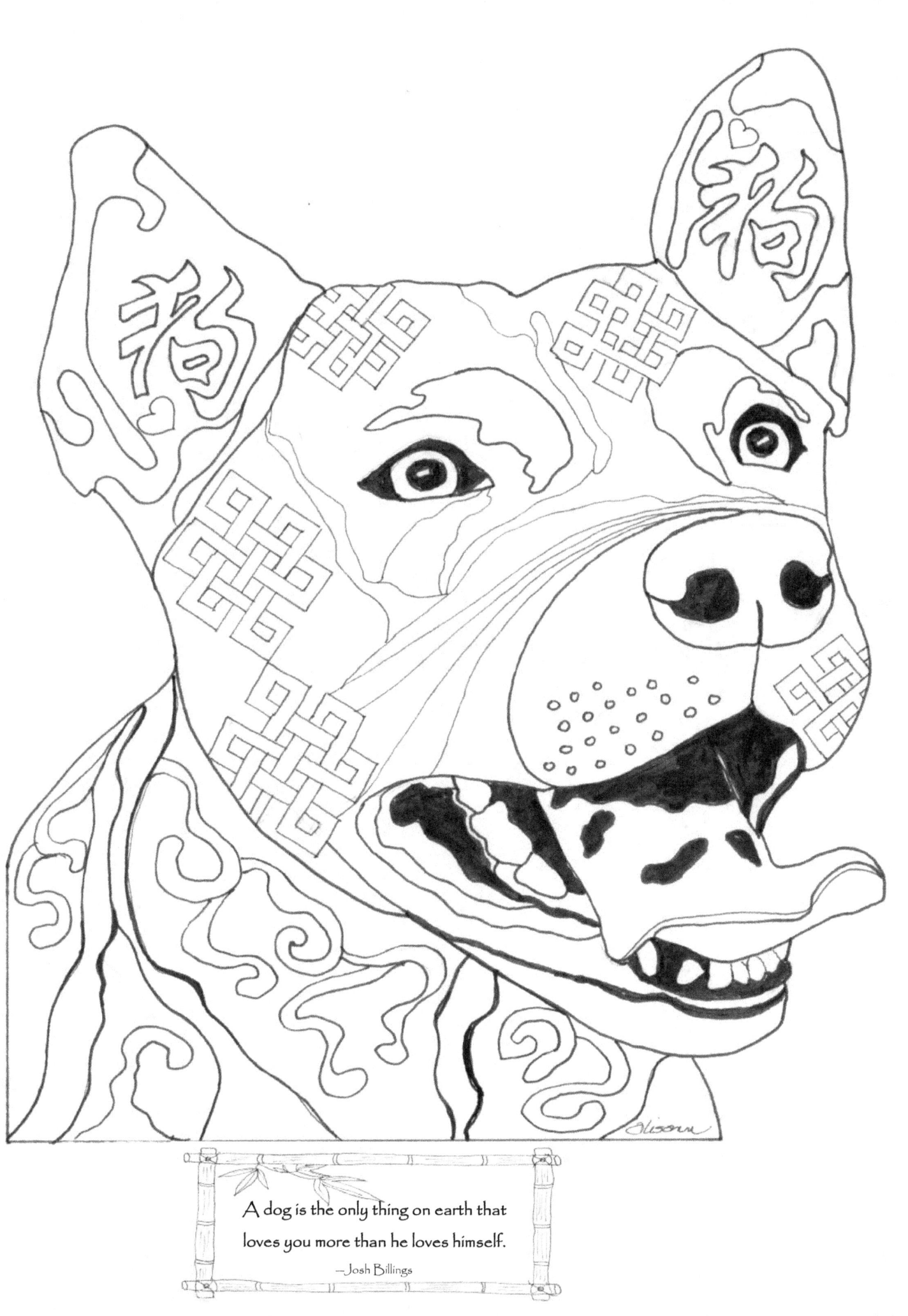

A dog is the only thing on earth that loves you more than he loves himself.
—Josh Billings

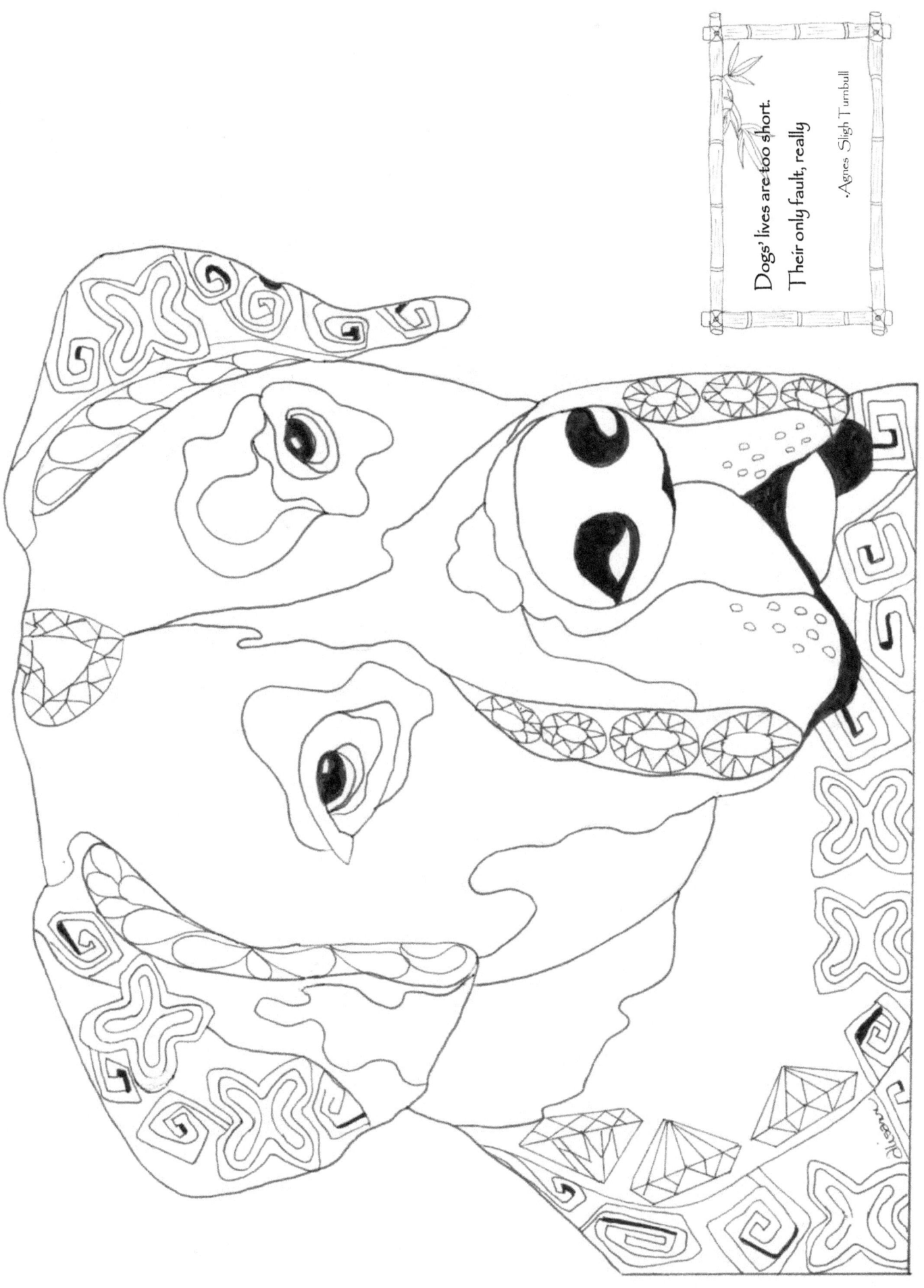

> Dogs' lives are too short. Their only fault, really
>
> —Agnes Sligh Turnbull

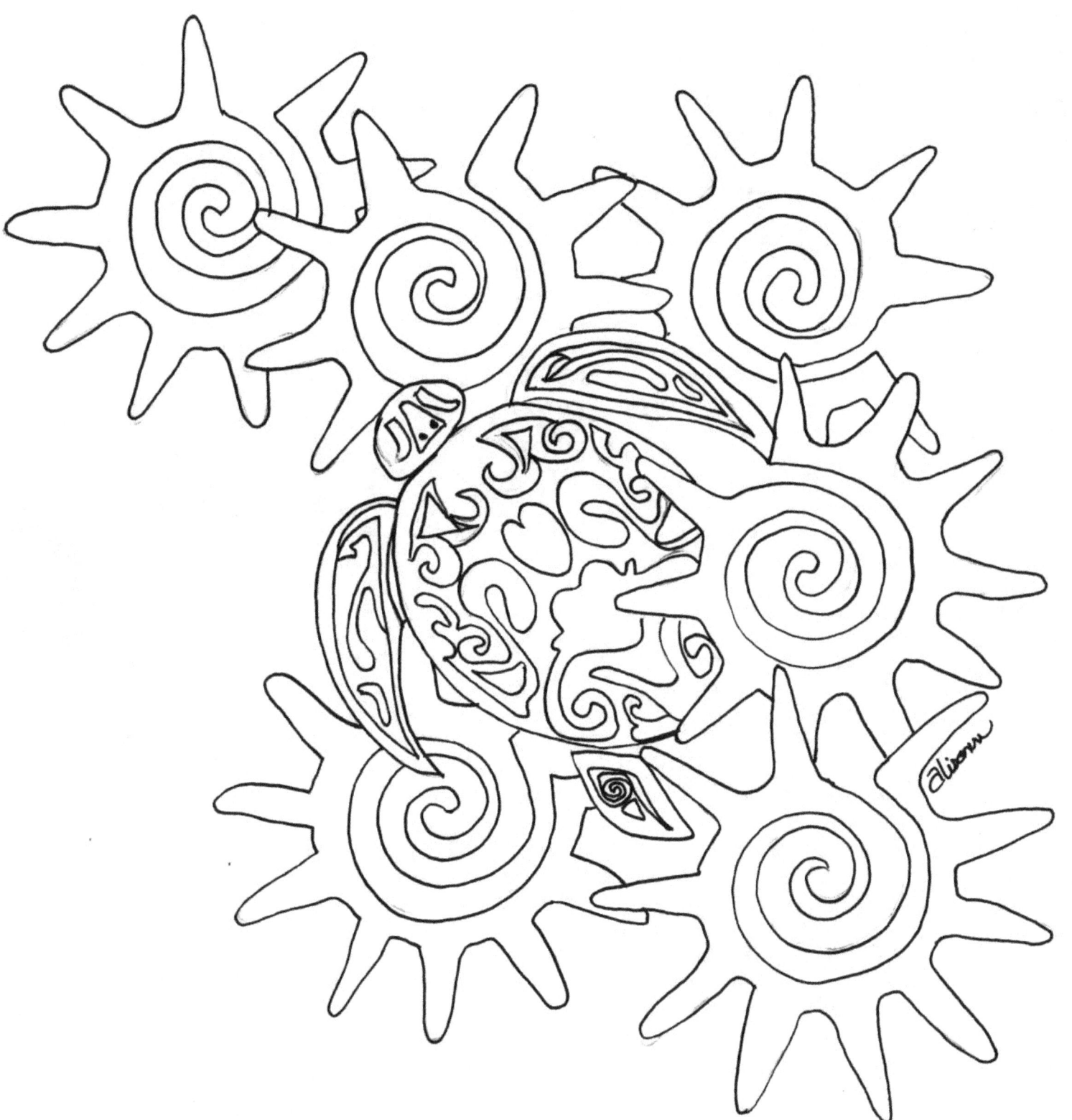

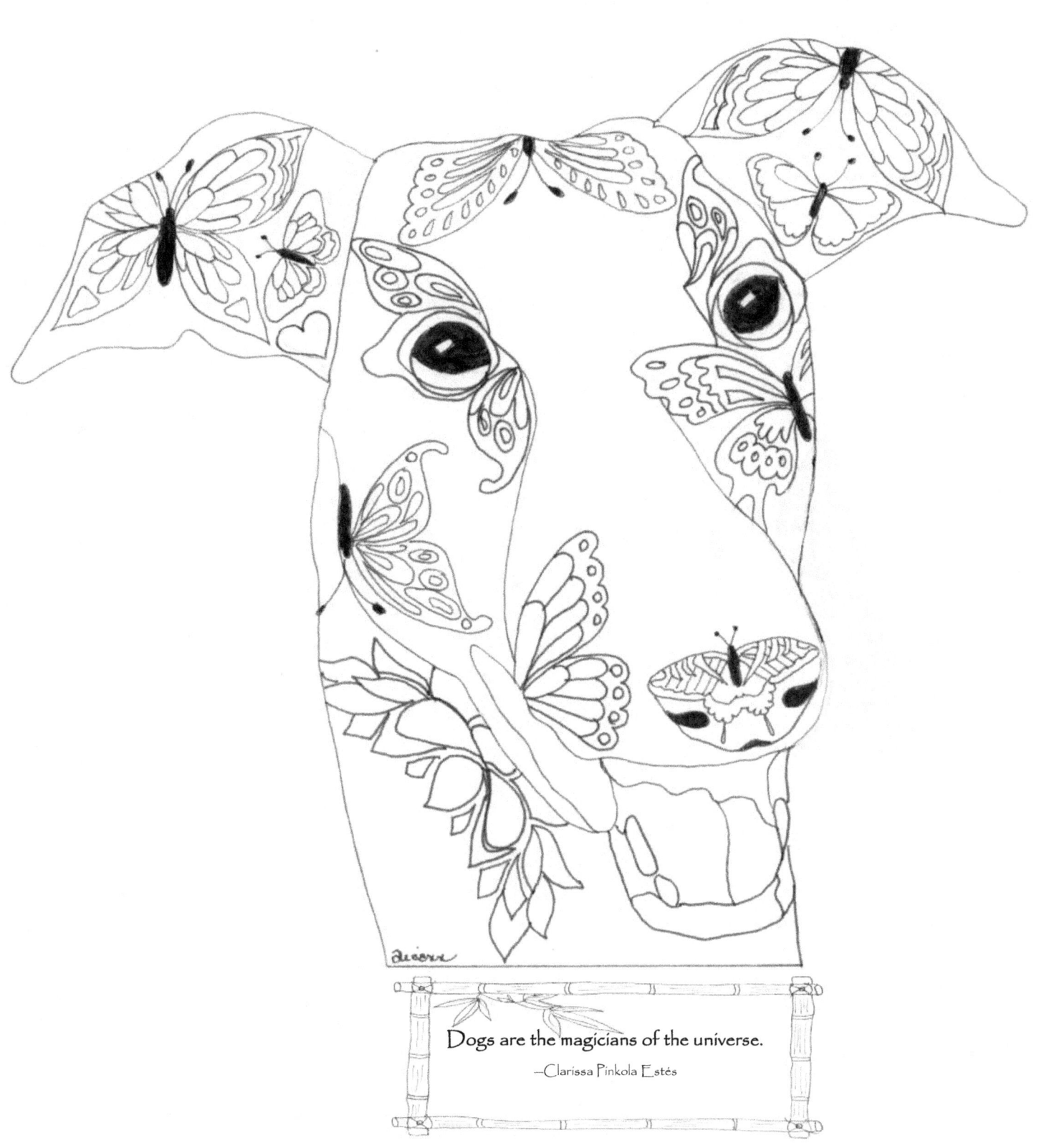

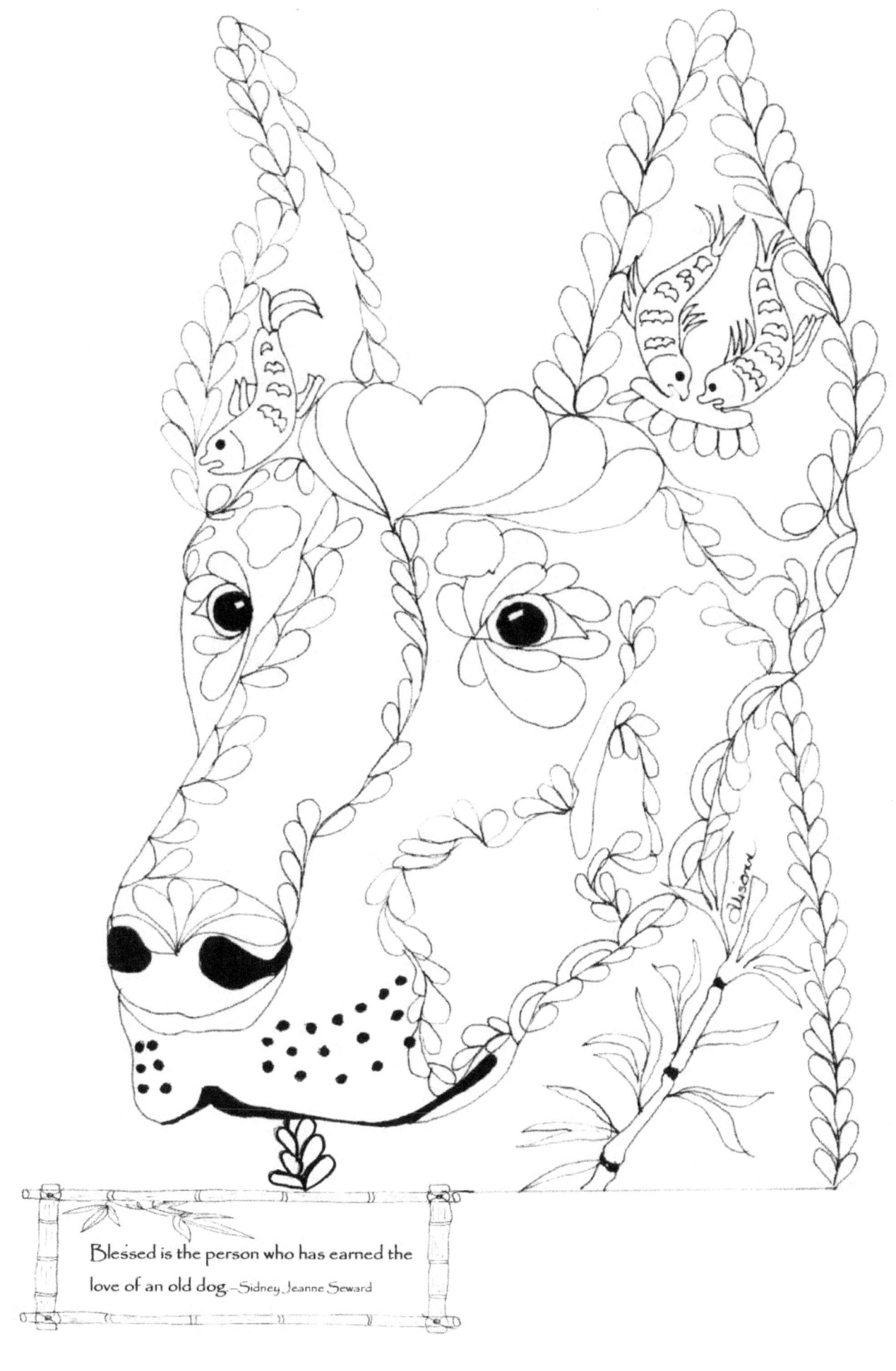

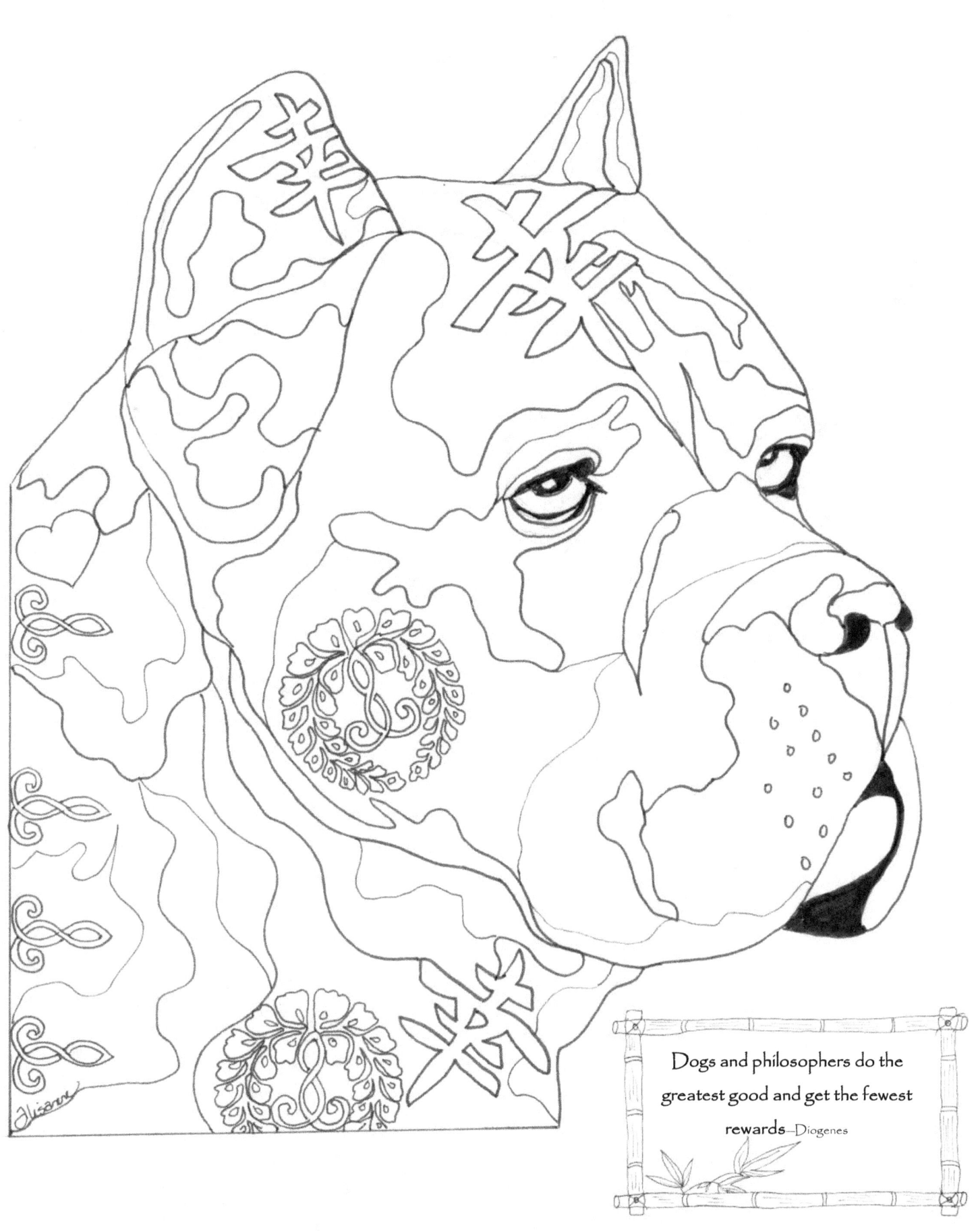

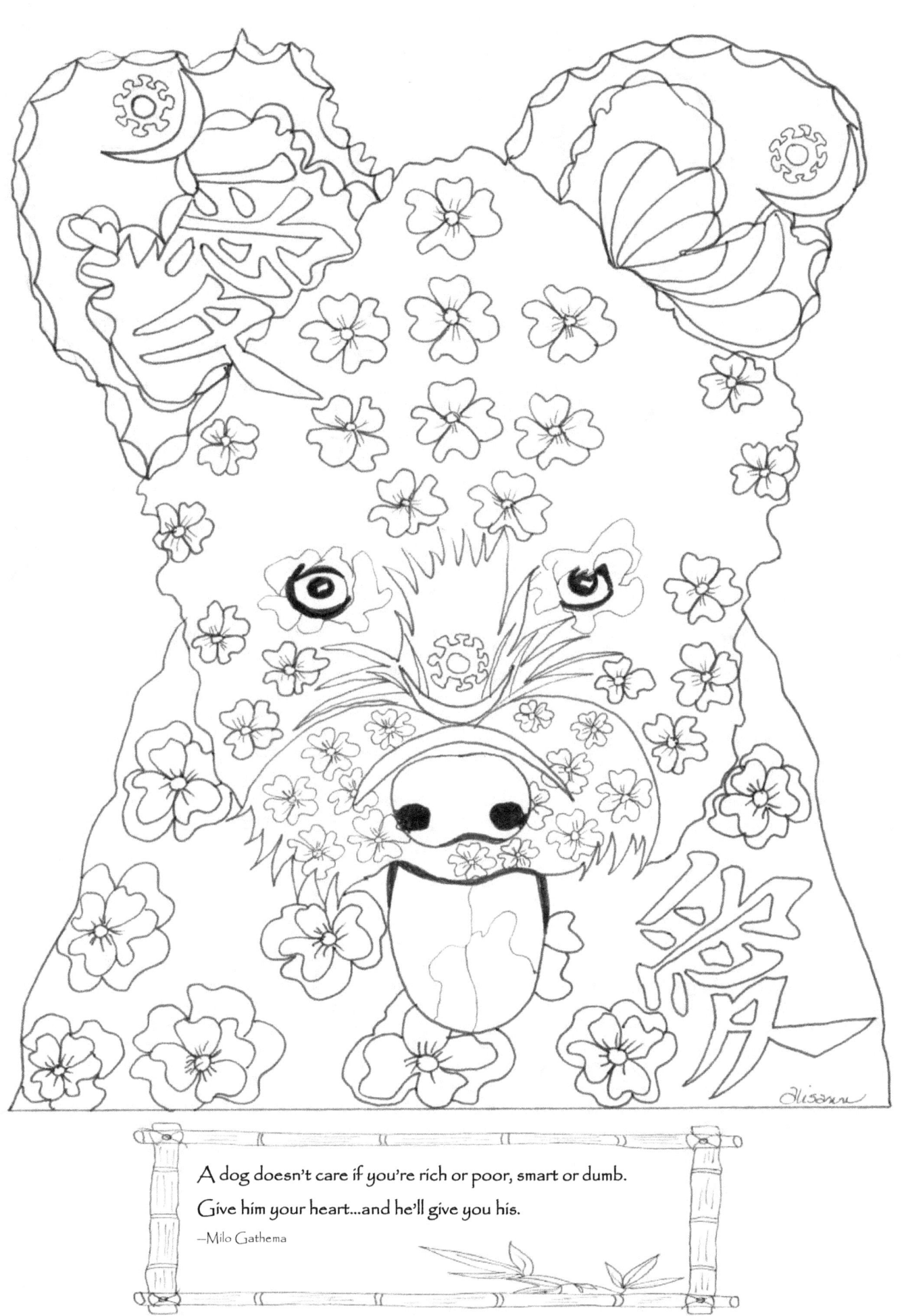

A dog doesn't care if you're rich or poor, smart or dumb. Give him your heart...and he'll give you his.
—Milo Gathema

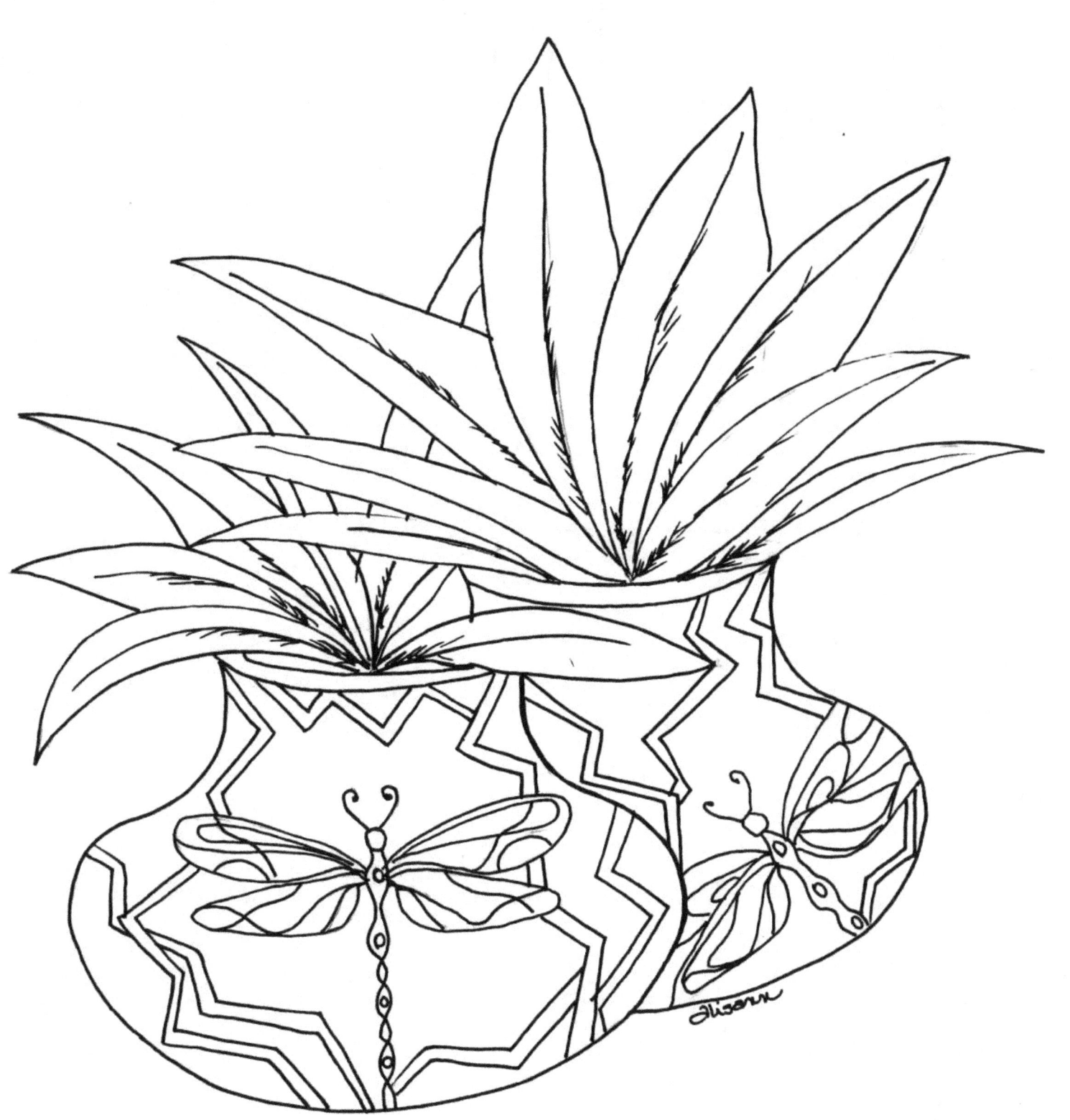

One of the happiest sights in the world comes when a lost dog is reunited with a master he loves. You just haven't seen joy till you have seen that. —Eldon Roark

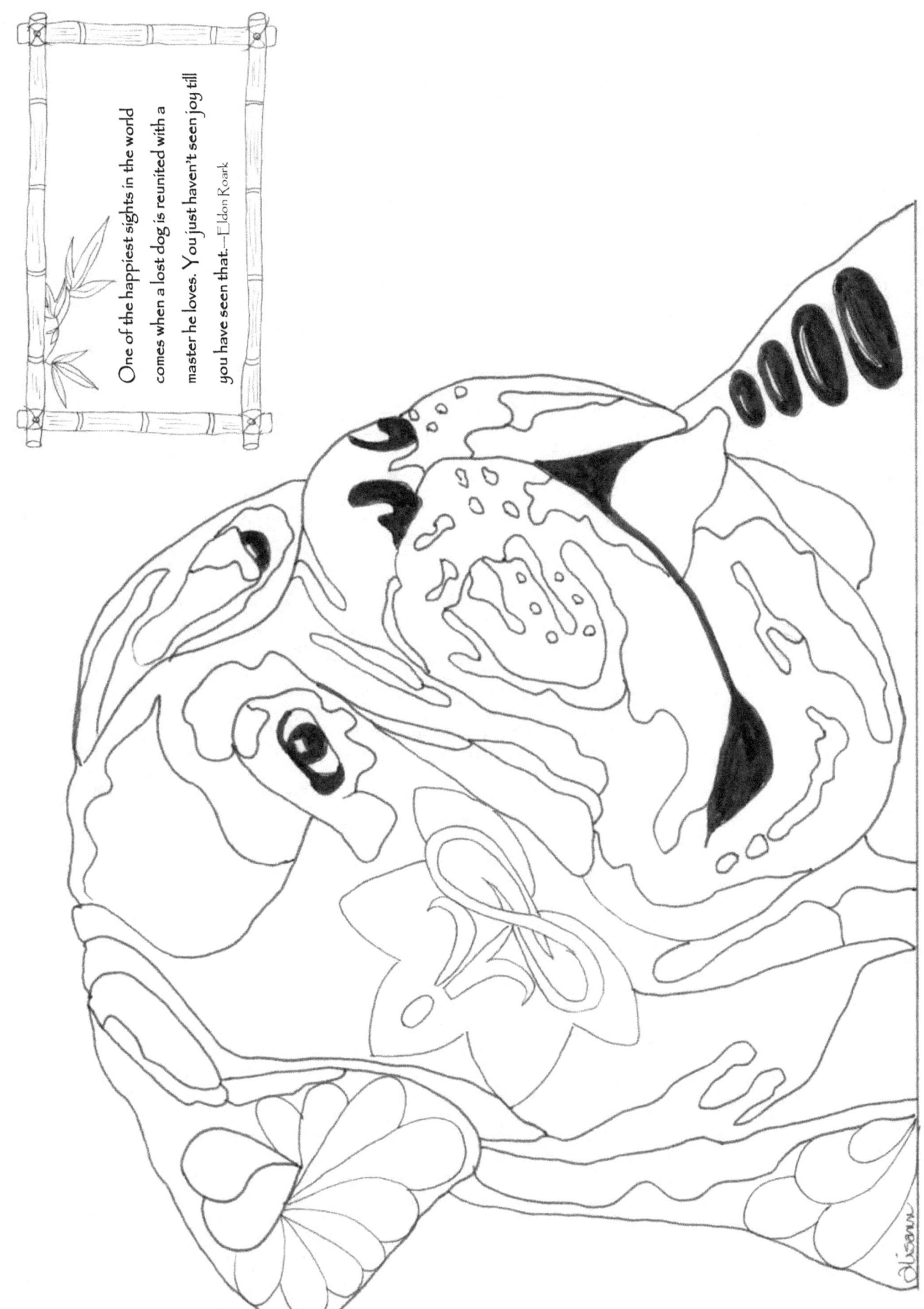

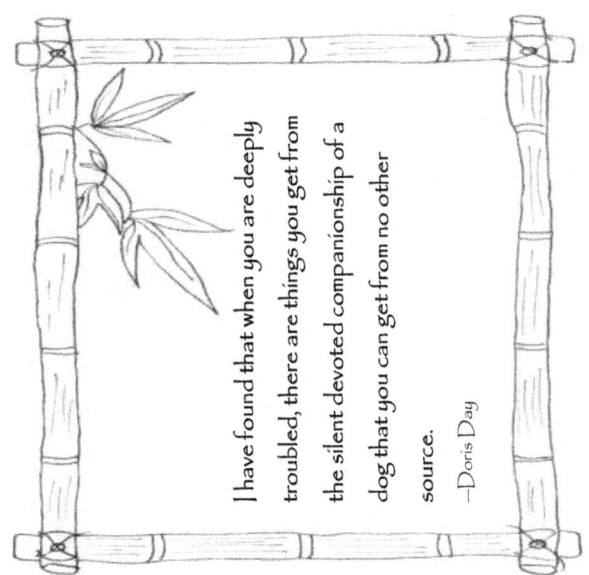

I have found that when you are deeply troubled, there are things you get from the silent devoted companionship of a dog that you can get from no other source.
—Doris Day

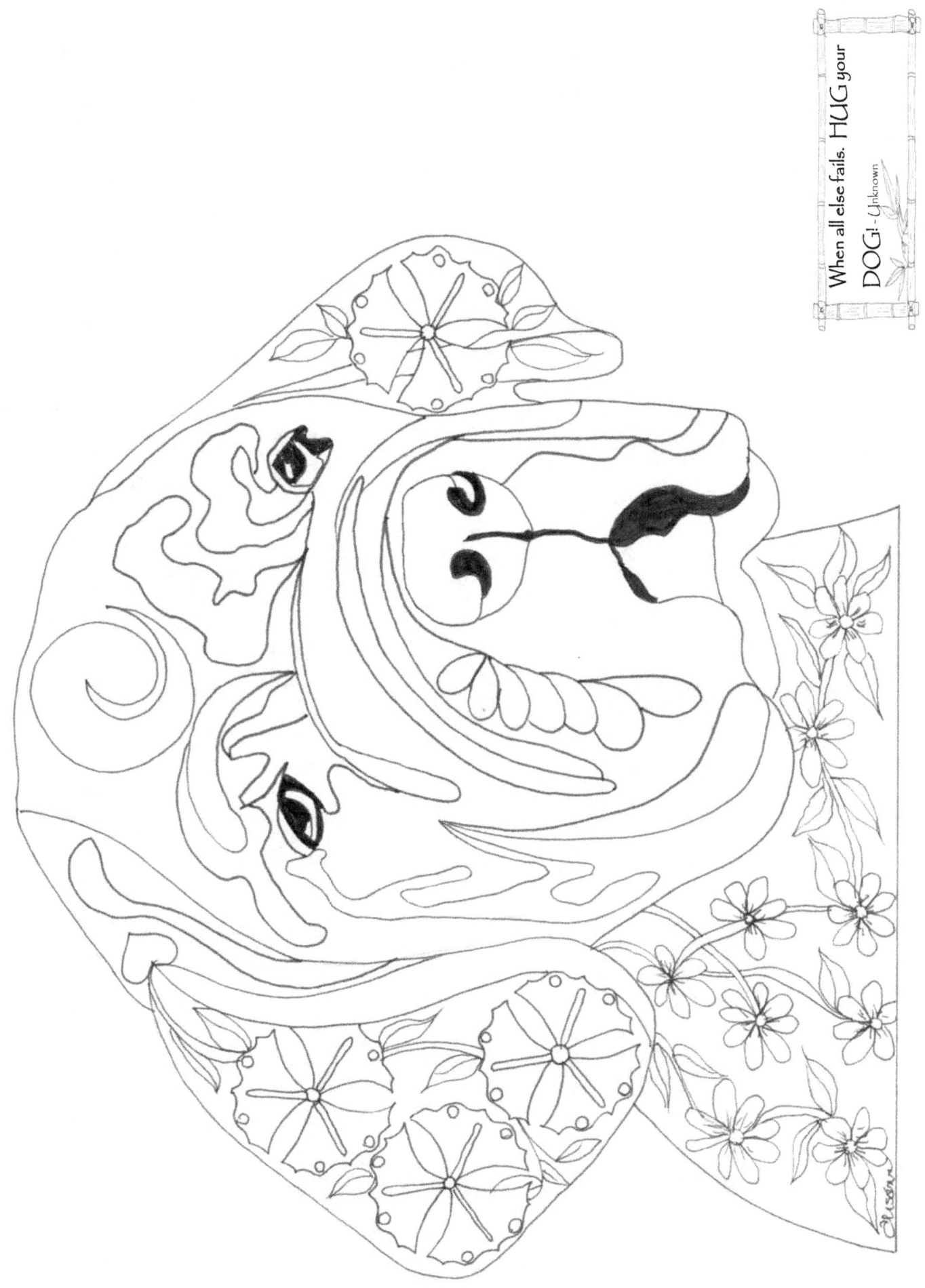

When all else fails. HUG your DOG! - Unknown

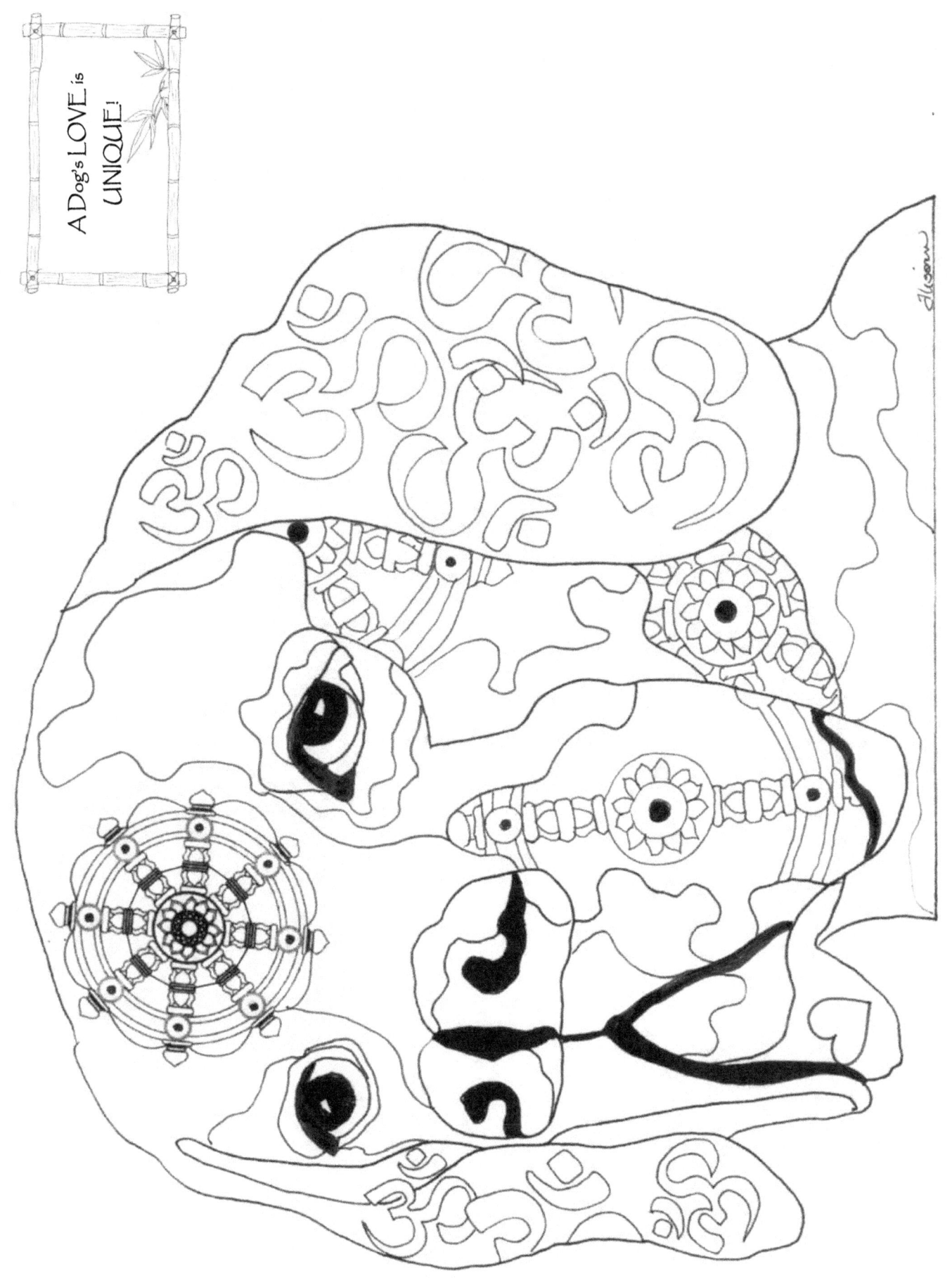

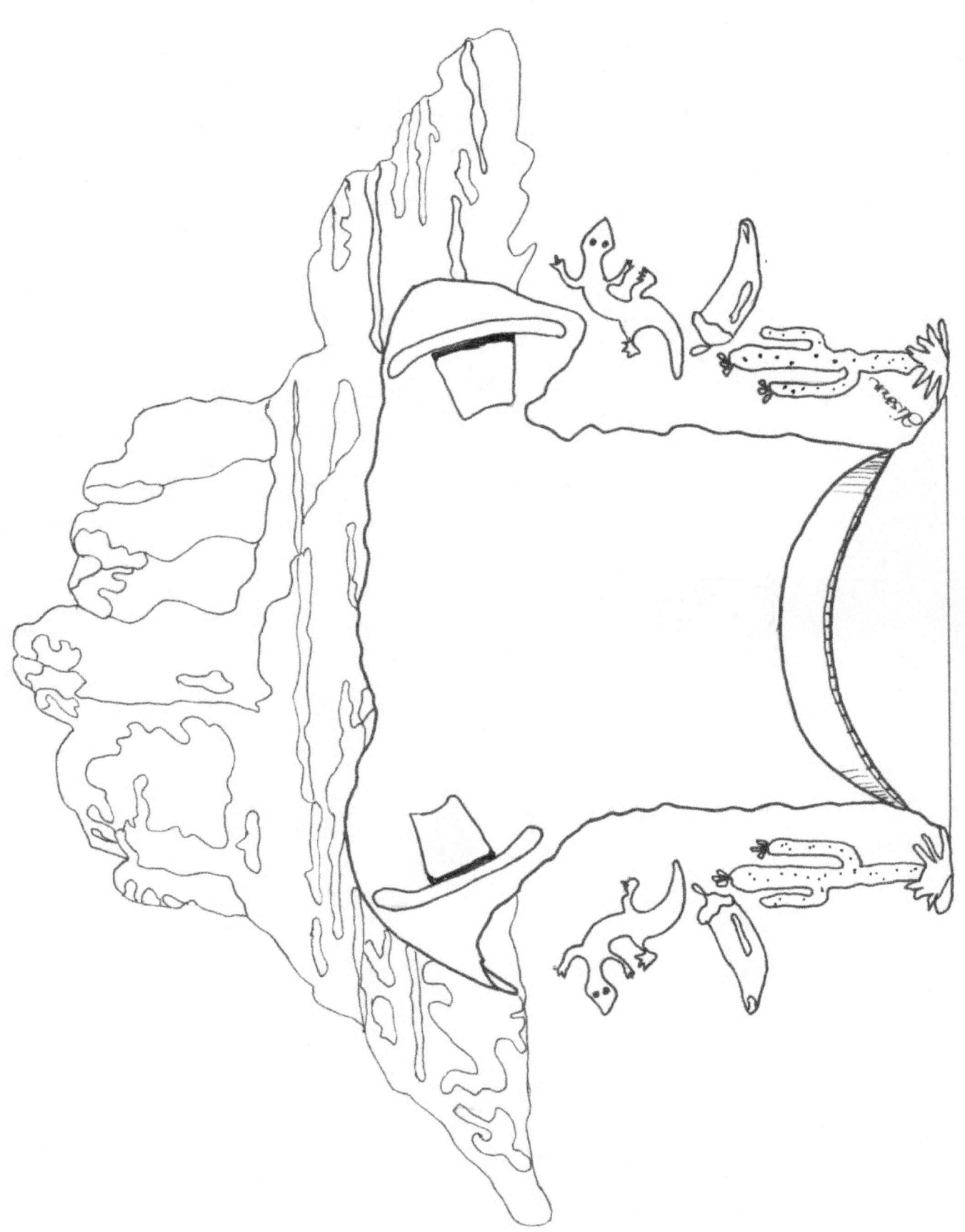

LOVE DOGS OF SEDONA

Other coloring books by Alisann

Love Dogs Vol. 1

Love Dogs Vol. 2

Love Puppies

Who Framed my Dog?

30 Shades of Grayscale—Dogs

30 Shades of Grayscale—Cats

My Trip to NOLA—Grayscale

40 Shades of Grayscale

Myndful Coloring Journal (Coloring Book and Journal)

Journal Your Colors (Coloring book and Journal)

You can find all her books on Amazon.com or at her

ETSY shop—AbeesArtStudio

Facebook—LoveDogsinColor and ArtbyAlisann

If you have any questions you can contact Alisann at

alisannsmookler@gmail.com

Reviews are always welcome as well.

Thank you!

www.ingramcontent.com/pod-product-compliance
Lightning Source LLC
Chambersburg PA
CBHW081119180526
45170CB00008B/2918